HOGARTH
THE PAINTER

HOGARTH
THE PAINTER

Elizabeth Einberg

Tate Gallery Publishing

Published by order of the Trustees
of the Tate Gallery by
Tate Gallery Publishing Ltd
Millbank, London SWIP 4RG

© Tate Gallery 1997

ISBN 0 85437 234 3

This catalogue is published to accompany
the exhibition organised by the Tate Gallery
from 4 March – 8 June 1997

front cover
The Graham Children 1742
(detail), no.18

A catalogue record for this book is available from the British Library

Designed and typeset by Caroline Johnston
Printed in Great Britain by Brown Knight and Truscott,
Tunbridge Wells

CONTENTS

FOREWORD

The last great Hogarth exhibition, organised by Lawrence Gowing, took place at the Tate Gallery in 1971–2, and coincided with Professor Ronald Paulson's two-volume publication of *Hogarth: His Life, Art, and Times*. Yet even this monumental work was not to be definitive: in 1991 Professor Paulson published a three-volume revised edition to include new research of the past twenty years. Some of this derived from work at the Tate Gallery, which, as the holder of the most important collection of Hogarth's works, published many new findings in its permanent collection catalogue, *The Age of Hogarth*, in 1988. But hardly a year goes by without the publication of new research on Hogarth, proving how inextricably this most individual of artists is involved with all aspects of the period. Surprisingly, there has been no *catalogue raisonné* of his paintings since R.B. Beckett's admirable volume of 1949. One hopes that this will be remedied in the not too distant future, for the completion of such a work would signal that the time is ripe for a new and truly comprehensive Hogarth exhibition that would include many new discoveries, and works that are better understood after cleaning and restoration.

In the meantime, the happy coincidence of the tercentenary of the birth of Hogarth, effectively the founder of the British School of painting, and the centenary of the founding of the National Gallery of British Art at Millbank can most appropriately be celebrated with a special display of the Tate's entire holdings of his works, augmented by a number of important loans from public and private collections.

We owe a great debt of gratitude to all those who gave so generously of their time and counsel to get this celebration off the ground. The organisers would like to thank Francis Greenacre for making possible a close scrutiny of Hogarth's Bristol altarpiece, although the sheer size of the work made its inclusion in the current display impractical, in spite of our combined enthusiasm for it. Pieter van der Merwe has been particularly helpful with documentation issuing from the National Maritime Museum, and Natalie Rothstein put her unrivalled knowledge of English textiles at our disposal with her usual generosity.

The support from lenders has been wonderful, and we are both honoured and delighted to be able to include the splendid *Mr and Mrs Garrick*, lent by Her Majesty The Queen. Our special thanks, however, must go to Mrs Gilbert Cousland, who has crowned our celebrations by presenting the enchanting pair of portraits of the Ranby children (nos.26 and 27) to the nation. Hogarth, who always strove to have more of his paintings on public display, would have surely been delighted, and we certainly are.

Nicholas Serota
Director

HOGARTH THE PAINTER

William Hogarth's first recorded venture into serious painting ended in court. In December 1727 the artist, by now thirty years old and with a respectable career in engraving and book illustration behind him, obtained a commission to paint the cartoon, or design, of a tapestry for Joshua Morris, a respected weaver in Soho. It was to represent *The Element of Earth*, an allegorical subject ambitious by any standards. When Morris grew nervous at Hogarth's lack of experience in this kind of work, he received a characteristically gung-ho reply to the effect that 'it was a bold undertaking, for that he never did anything of that kind before, and that if … [Morris] did not like it, he should not pay for it'. In due course Morris decided that he did not like it and refused to pay, not because the painting was poor, but because he said it was impossible to weave from. After making some adjustments, Hogarth sued for payment, and won. Sir James Thornhill (*c.*1675–1734), the leading British decorative painter of the age and Hogarth's future father-in-law, was one of several established artists who vouched for Hogarth's competence as a painter. The cartoon has not survived, and so we do not know what Hogarth's first commissioned painting was like. The episode does, however, demonstrate that Hogarth did not begin timidly, with modest, little pictures, but staked a claim to be regarded as a serious painter of sublime and allegorical subjects from the outset, and did so with an almost foolhardy pride in rising to challenges in a field where he had no previous experience.

We know very little of how and where Hogarth learnt to paint. He was apprenticed to the silver engraver Ellis Gamble for seven years, chiefly because Hogarth's family was too poor to place their obviously gifted son with a painter, and no painter's name attaches to his early years to suggest from whom he could have received even casual instruction. As soon as he could, in 1720, he subscribed to the newly formed 'Academy for the Improvement of Painters and Sculptors by drawing from the Naked' in St Martin's Lane, where he would have become acquainted with most of the artists then working in London. In his *Autobiographical Notes*, written at the end of his life, Hogarth fostered the image of self-taught originality, stressing that throughout his long apprenticeship he chafed at 'the Narrowness of this business', while Thornhill's huge undertakings of painting St Paul's Cathedral and the Greenwich Hospital were all the time 'running in my head'. He does however say that he was assiduous in training his unusually powerful visual memory and he does admit to having learnt to copy the Old Masters 'in the usual way … with tolerable exactness', before deciding that the method was too tedious and inhibited the imagination. It is clear that Hogarth, short of stature (reportedly five foot 'or less') and lacking all material advantages, set out from the start to make a big impression on the world.

Nothing fired his imagination more than the theatre. People of humble origins

achieved stardom there on their own merits, and everything seemed possible on the stage. Actors, scenery painters, playwrights, impresarios and theatre enthusiasts remained close to him all his life, and he felt more at ease in their company than anywhere else. His first great success in painting was the record of an actual stage performance, *The Beggar's Opera* (no.2) in 1728, and the increasingly elaborate and confident treatment of the five successive versions of this subject over the next three years bears witness to his astonishingly fast development as a painter. The liveliness of the theatrical performance soon came to colour his approach to the small-scale informal group portraits, or conversation pieces, that had come into fashion, raising them well above the stiffly regimented groupings of his contemporaries. 'Subjects I consider'd as writers do; my Picture was my Stage and men and women my actors', he wrote in one of his many analogies between painting and the theatre. He was also unique in striving to express action and emotion, not only through the conventionally accepted canon of gestures as laid down in academic pattern books, but through instances of sharply observed natural movement which he would try to capture in a snapshot-like image.

The theatre continued to play an important role throughout his painting career. After *The Beggar's Opera* Hogarth turned to Shakespeare and painted *Falstaff Examining his Recruits* from *Henry IV*, signed and dated 1730 (private collection), and a larger and more elaborate composition based on *The Tempest* (Nostell Priory). Neither of them appear to record an actual performance, and are therefore in some respects closer to 'history painting'. *The Indian Emperor* (no.4), the masterwork of his early years, is again the record of a real performance of a tragedy by Dryden as well as of a social occasion. In 1745 theatre and portraiture fused in a life-size portrait of *Garrick as Richard III* (fig.1; Walker Art Gallery, Liverpool). Garrick's performance of this part took London by storm in 1741, and launched him on his career as the most famous actor of the eighteenth century. It was evident to Hogarth that prints of this subject would sell well, and Garrick, who like Hogarth was an inspired self-publicist, was a willing sitter. The portrait, painted in the grand manner with more than half a glance at Italian and French Baroque precedents, was enormously successful both as a print and as a painting, and was soon bought by Thomas Duncombe, a wealthy Yorkshire landowner, for £200, an unheard-of sum for a contemporary portrait. Garrick and Hogarth remained friends for life.

By about 1730 Hogarth had more commissions for small-scale conversation pieces than he could comfortably cope with (see no.3). He also realised that the labour in producing these was not in his case commensurate with the one-off fees that they commanded. Good income came through having a large portrait practice, where the master laid in the head and general pose, and then had the painting finished by low-paid specialist drapery and background painters, a practice which Hogarth abhorred since it gave most portraits of the period a uniformly glossy, undifferentiated air. The other was to paint portraits of well-known people whose images would sell in engraved form, be they common criminals or archbishops. Hogarth hit upon a third form: engraved sets of prints after well-painted original works of his own invention that presented a dramatic story like successive

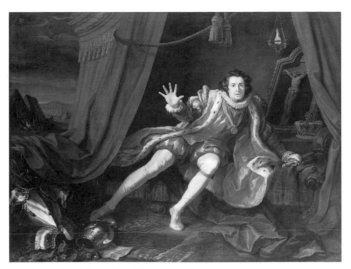

fig.1 *Garrick as Richard III* 1745, oil on canvas 190.5 × 251.2 cm
The Board of Trustees of the National Museums & Galleries on
Merseyside (Walker Art Gallery, Liverpool)

scenes from a play, in richly textured, inexhaustibly readable detail. Thus came into being his 'modern moral subjects', the famous narrative cycles that began at first with two-part versions of titillating erotic genre like *Before* and *After* of 1730 (Fitzwilliam Museum, Cambridge, and Getty Museum, Malibu), and which then progressed to more sustained moral tales like the six-part *Harlot's Progress* (destroyed) in 1732, followed by *The Rake's Progress* (Sir John Soane's Museum) in 1735, *The Four Times of Day* in 1736 (National Trust and Grimsthorpe Castle Trustees), the *Marriage A-la-Mode* of 1743 (National Gallery, London), and the never completed *Happy Marriage* of 1745 (see nos.21–2). While the prints after these brought him moderate wealth and international fame, the original oils proved more difficult to sell, and Hogarth produced a number of popular narrative sets from drawings only. In 1754, however, he returned to oils to paint the magnificent sequence of the four scenes of *The Election* (Sir John Soane's Museum), an indelibly memorable comment on political life and mores in Britain in the middle of the eighteenth century. In between he painted grand narrative tableaux like *The Gate of Calais* (no.25) that reflected topical issues in rich, allusive detail and sold well as individual prints. This enterprise required organisational abilities which involved advertising in the press, the management of engravers, bringing in subscribers to the prints and the collection of down payments, and of final payments on delivery. Hogarth, it appears, was an excellent business man, with a genius for spotting a new market. He never let down his subscribers and was scrupulously honest with money. He often had his images engraved expensively by highly skilled French engravers for the upper end of the market, and at the same time cheaply and in reduced size for more general sales. In this sense his practice as an engraver and the print business never ceased to support his work as a painter, and it is significant that Hogarth was the moving spirit behind the Engravers' Copyright Act of 1735 which aimed to prevent the manufacture of cheap pirated prints which bit into the profits of the original artist.

No professional painter could survive in Britain without painting portraits, either of people or, in the case of landscape painters, of people's houses. Hogarth's success as a comic history painter of decidedly sleazy subjects doubtlessly stood in the way of his gaining the patronage of the upper echelons of fashionable society or the court, although as a portrait painter he never lacked admirers among the wealthy professional classes and the more eccentric members of the aristocracy. His strength lay not in the smooth finish and nonchalant elegance of successful contemporaries like Hudson and Ramsay (whom he greatly admired), but in a highly individual broad-brush approach that treated the face not as a mask but as a mobile organ that could convey fleeting expressions and physical presence. As conventional manners dictated that a set and serene countenance was a mark of good breeding, this latent vivacity – especially in women – could appear shocking and coarse and lacking in grace. Nevertheless, Hogarth was to become the leading portrait painter of the 1740s and most of his best portraits date from that decade, which began with the completion of the magnificent *Captain Coram* (no.11) and which includes such supreme examples of Rococo portraiture in Britain as *The Graham Children* (no.18) and *The Mackinen Children* (no.24). All are remarkable for their emphasis on character over fashionable formulas, even in portraits of children. He was always careful not to get himself categorised as a portrait painter, and was proud to point out that he achieved many of his successes without the constant practice these things were said to require. In the 1750s he gave up portrait painting to concentrate on history subjects, but on meeting with disappointment in this line he very publicly announced in 1757 that he was back in the market as a portrait painter.

At no point in his career did Hogarth cease to aim for the highest prize a contemporary painter could achieve, which was to be recognised as a serious 'history painter', that is, a painter of sublime subjects from the Bible, ancient history and literature. Mastery of this 'Grand Style' raised a painter above a mere craftsman and conferred upon him intellectual dignity and social consequence. It required familiarity with classical literature and the Old Masters of the Renaissance, and with the established painting traditions of Italy and France. Most of all it demanded the ability to convey notions of grandeur and nobility in action as well as in expression, and to work on a large scale. Spurred on no doubt by the success of Sir James Thornhill, the first native-born painter to achieve fame, wealth and title through his art, Hogarth hoped to inherit his mantle. Thornhill's career had flourished partly because it coincided with the fashion for magnificently painted Baroque interiors and partly because of the patriotic anti-Catholic fervour that came with the Hanoverian succession, creating a climate in which British-born painters were favoured over foreign (usually Catholic) ones. Hogarth tried singlehandedly to revive the fashion for large-scale decorative work, a hopelessly quixotic task, since there was virtually no patronage from the Church and the British monarchy had little inclination to seek to enhance its prestige through art, as was the custom in some Catholic and more authoritarian countries.

There was, however, one area where Hogarth saw the possibility of publicly vis-

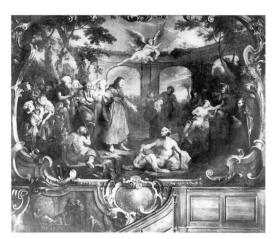

fig.2 *The Pool of Bethesda* 1736,
oil on canvas 416.5 × 617 cm
St Bartholomew's Hospital, London

fig.3 *The Good Samaritan* 1737,
oil on canvas 415 × 615 cm
St Bartholomew's Hospital, London

ible institutional patronage. London, the largest and fastest growing city in Europe, was experiencing a building boom in hospitals, which were increasing rapidly in number and size. All had grand public rooms where their governors, generally elected from among the great and the good, met and to which the beau monde was admitted to stimulate public support. St Bartholomew's Hospital, near Hogarth's place of birth in Smithfield, had added a new wing and in 1734 had all but secured the Venetian Giacomo Amiconi to decorate its grand staircase. Although untrained in the technique of Grand Style painting, Hogarth offered to do the job for free and, with the prestige of Thornhill and some patriotic string-pulling behind him, secured the commission. His two enormous canvases on the suitably elevated subjects of *The Pool of Bethesda* (fig.2) and *The Good Samaritan* (fig.3) were installed in 1736 and 1737 respectively and were universally admitted to be remarkable performances for someone untrained in this branch of painting. Hogarth modelled himself on the great Raphael Cartoons depicting the Acts of the Apostles which were then at Hampton Court (now in the Victoria and Albert Museum). These had been extolled as the epitome of the Sublime by commentators from the seventeenth century onwards and were among the best known works of art in Europe. Hogarth, moreover, would have had plenty of opportunities to study them, and not only from prints. He may even have helped his father-in-law Thornhill when he was making official copies of them, both full-size (now in the Royal Academy) and small, in 1728–31, with a view to publishing a book of details from them as models for students to imitate. Such intimate contact with the work of one of the greatest of the Old Masters would have encouraged Hogarth to feel that he was well qualified to undertake any modern commissions on a similar scale. And if anyone had remarked on the fact that Hogarth had surrounded the figure of Christ and the lame man in the *Pool of Bethesda* by a crowd of people suffering

from various clinically recognisable diseases – one of the most remarkable if gris-ly features of this canvas – in a way that offended against the accepted idealising notions of the Grand Style, the artist could point to the graphically depicted crip-ples in Raphael's cartoon *Healing the Lame Man* and say that he was only following in the footsteps of the master.

Hogarth was elected to the board of governors of at least three London hospi-tals, either for donating works or for advising on their decoration. His most long-lasting and fruitful association was to be with the new Foundling Hospital, probably because of a personal rapport with its founder Captain Thomas Coram (no.11), and because the fate of orphans touched the childless Hogarth more deeply than other causes. The institution also caught the public imagination and the hospital became the most popular charity in the capital. After presenting the portrait of Coram in 1740, Hogarth quickly saw that the generously large but puri-tanically bare buildings under construction (the Governors refused to spend any money on decoration) would become a meeting place for London society and con-ceived the idea of making them into a showcase for contemporary British art. He worked out a suitably Protestant programme on the rescue of children and good works (in this case, the building of hospitals) and presented in 1746 his most suc-cessful large history piece, *Moses before Pharaoh's Daughter* (fig.4) to the newly opened institution. More than that, he persuaded leading contemporaries – High-more, Hudson, Rysbrack, Wilson, Lambert, Gainsborough, Hayman, Brooking and others – to follow suit. Their works are still in place at the Coram Foundation, making it the most representative artistic ensemble of the 1740s to survive in this country. For the artists, the Foundling Hospital became a focal point of their com-munity until public exhibitions of contemporary art became possible with the establishment of the Society of Arts in 1760.

fig.4 *Moses before Pharaoh's Daughter* 1746,
oil on canvas 177.7 × 238.7 cm
Thomas Coram Foundation for Children, London

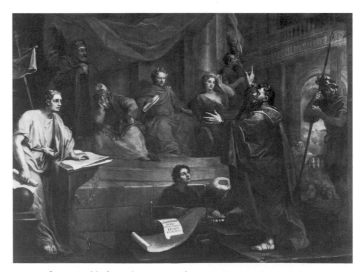

fig.5 *Paul before Felix* 1749, oil on canvas 304.6 × 426.6 cm
The Honourable Society of Lincoln's Inn, London

The Foundling Hospital enterprise probably brought Hogarth his next challenge: in December 1747 the lawyers of Lincoln's Inn, at the instigation of William Murray (the future Lord Chief Justice Lord Mansfield) decided to use a legacy of £200 'for a picture to be drawn by Mr Hogarth, to be placed against the wall at the west end of the Chappel'. The serious nature of this request prompted Hogarth to model himself more determinedly than ever on the Raphael Cartoons in an attempt to prove himself a worthy protagonist of the Grand Style, perhaps even to win the accolade of being the English Raphael, just as his friend the landscape painter George Lambert had been hailed as the English Poussin. In *Paul before Felix* (fig.5) he chose as his subject the great courtroom drama from the Acts of the Apostles, where St Paul, accused of inciting rebellion against the state, defends himself before Felix, the Roman Governor of Judea. This was a passage which his friend Bishop Hoadly (no.14) had highlighted in his writings as establishing the superiority of moral law over temporal power, a subject both suited as an additional scene to the Raphael Cartoon series, and appropriate for its setting in a court of law. So concerned was Hogarth to equal the Cartoons in scale that he failed to take note of the size of the west end wall of the chapel: when completed, it became apparent that the picture was too large for the space and it was finally hung in the hall in 1750, above the Lord Chancellor's seat. The contemporary art commentator George Vertue, who was on the whole not very sympathetic to Hogarth, saw it as 'a great work' that showed 'the greatness and magnificence of Mr Hogarth's genius' and thought it brought 'much honour so that raises the character of that little man – tho' not his person'. Apart from the near-identical size, many gestures, details and figures are borrowed from the Raphael Cartoons, as indeed is the broad and summary brushwork. What interferes with its intended monumentality is Hogarth's inability to distance himself from the theatrical exaggeration which his small modern subjects had carried off with such ease, and his determination to put more 'life' into his figures than Raphael had done.

In 1755, by now recognised as a leading British history painter, Hogarth received his most unusual and extraordinary commission, to paint a huge triptych altarpiece of *The Ascension* (fig.6) for the Church of St Mary Redcliffe in Bristol, with wings depicting *The Sealing of the Tomb* (fig.7) and *The Three Marys at the Empty Tomb* (fig.8). It was painted in London, and Hogarth supervised its installation in July 1756. The broad, almost coarse brushwork for which Hogarth has been criticised is appropriate for a work designed to be seen from about the same distance as a theatrical flat, and the composition is designed to make its effect through its flowing and dynamic lines and clear, bright, typically eighteenth-century colouring. It is this, and the rainbow-tinted light surrounding the risen Christ, that make this one of the most impressive religious pictures painted in Britain. Although he received the considerable fee of £525 for it, and probably because he realised that the magnitude of this commission had brought him to the limits of his artistic capabilities and even, possibly, his physical strength, he announced in 1757 his intention to return to portrait painting.

The most outstanding work of these late years is the double portrait of *Mr and*

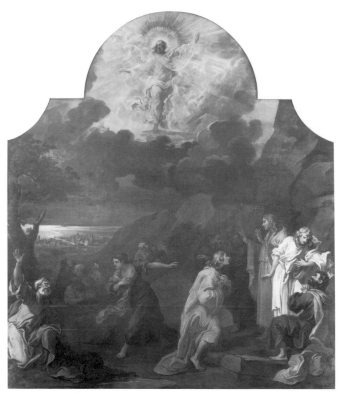

fig.6 Altarpiece for St Mary Redcliffe, Bristol (Triptych) 1755–6,
The Ascension, oil on canvas 672 × 584 cm
City Art Gallery, Bristol (St Nicholas Church Museum)

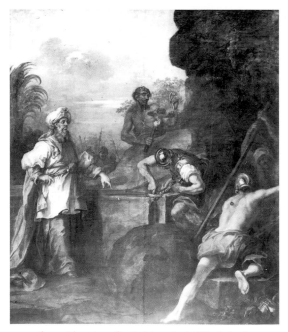

fig.7 Altarpiece for St Mary Redcliffe, Bristol
(Triptych) 1755–6, *The Sealing of the Sepulchre*,
oil on canvas 422 × 364 cm
City Art Gallery, Bristol (St Nicholas Church Museum)

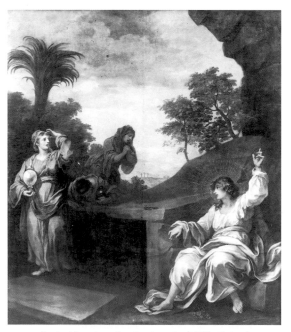

fig.8 Altarpiece for St Mary Redcliffe, Bristol
(Triptych) 1755–6, *The Three Marys at the Tomb*,
oil on canvas 422 × 364 cm
City Art Gallery, Bristol (St Nicholas Church Museum)

Mrs Garrick (no.29), but on the whole he painted less and less, busying himself with art historical theory and debate. In 1758–9 he was prevailed upon to venture once more into the realms of comic history with the delightful late Rococo genre piece *The Lady's Last Stake* (Albright-Knox Art Gallery, Buffalo) which brought him his final taste of real success. At the same time he put his all into his last sublime history, *Sigismunda Mourning over the Heart of Guiscardo* (no.30), and was devastated by its failure. After the debacle of *Sigismunda* he all but gave up painting. The seven pictures he exhibited in 1761 at the Society of Artists had all, with the possible exception of some of the unidentified portrait heads, been painted several years before, and they were carefully chosen to represent him as a painter of comic and sublime history and as a portrait painter. This resistance to being pigeonholed into any one of the accepted academic categories of painting was probably one of the factors which drew upon him the hostility and criticism of an increasingly academically minded artistic community: he was now seen as unfit to pronounce on artistic theory as he had done in his only work on the subject, *The Analysis of Beauty*, published in 1753. This had been initially well received, but was now reviled in increasingly bitter disputes between various factions of artists. Hogarth had become an isolated figure. In spite of failing health, the habit of boldly rising to challenges, which he had demonstrated in his youth with Joshua Morris, had not left him, and his last years were spoilt to a certain extent by public bickering from which even his friends could not protect him. Hogarth spent the rest of his time revising his prints and making jottings for a sequel to the *Analysis* and for an autobiography, none of which developed very far. Yet by the time he died in October 1764 he had left so indelible a mark on the history of British painting that the term 'Hogarthian' remains instantly comprehensible even today as a valid description of a wry, satirical perception of the human condition.

While we take his lasting success as a satirical engraver for granted, the success of Hogarth as a painter remains something of a mystery. In E.K. Waterhouse's just phrase, it seems that 'he must have been endowed from heaven with a gift for handling the medium of oil paint'. He had a feeling for its texture and sensual qualities unmatched by any British painter of the time, and he could use it with an inventive freedom or delicate precision that is startling even today: few painters commanded a technique that could range from the slashing energy of Archbishop Herring's sleeve (no.19) to the controlled focus of the Graham children's cat (no.18). His assurance wavered only when he laboured to fit into essentially uncongenial prevailing rules of grandeur, at which point his work registers both the strain and the excitement of taking high risks in hostile territory. He was totally successful when he worked within a field that he had practically created for himself – painting the tragi-comedy of contemporary life. It is fitting therefore that in his last self-portrait, painted in about 1758 (National Portrait Gallery), Hogarth portrays himself as a painter at work, palette-knife grasped aggressively in hand, gazing with intense concentration at a large canvas on which is sketched in outline the jealous mistress who never quite let him go, the Comic Muse.

CHRONOLOGY

1697 10 November: William Hogarth born in St Bartholomew's Close, Smithfield, son of Richard Hogarth, schoolmaster and compiler of school texts
28 November: baptised at St Bartholomew the Great

1702 23 April: coronation of Queen Anne

1703 Family moves to St John's Gate, where Richard Hogarth opens a Latin-speaking coffee house

1707 Thornhill commissioned to paint allegory of the Protestant Succession in the Great Hall of Greenwich Hospital

1707–8 Richard Hogarth confined to Fleet Prison for debt after failure of coffee house. Family lives within the prison Rules (i.e. a limited area nearby where 'open prison' type rules applied)

1712 12 September: Richard Hogarth freed from prison by act of amnesty for debtors owing under £50. Family moves to Long Lane

1713 2 February: William Hogarth begins seven-year apprenticeship to silver engraver Ellis Gamble, Leicester Fields

1714 1 August: death of Queen Anne
20 October: coronation of George I

1715 28 June: Thornhill commissioned to paint dome of St Paul's Cathedral

1717 Thornhill completes painting the dome of St Paul's Cathedral

1718 11 May: death of Richard Hogarth
Thornhill appointed History Painter in Ordinary to the King

1720 23 April: William Hogarth sets up business as engraver in his mother's house in Long Lane
2 May: Thornhill appointed Sergeant Painter to the King and knighted
20 October: Hogarth subscribes to newly set up St Martin's Lane Academy (which folds after a few years when treasurer embezzles funds)

1721 Thornhill completes decorative work in St Paul's Cathedral
Hogarth publishes first satirical print, works on book illustrations

1724 Hogarth joins Thornhill's free academy in Covent Garden

1725 Thornhill becomes Master of his Masonic Lodge
27 November: earliest record of Hogarth as Freemason
12 June: death of George I

1727 11 October: coronation of George II
20 December: Hogarth commissioned to paint allegorical tapestry design for Joshua Morris

1727–31 Thornhill works on full-scale copies of Raphael Cartoons at Hampton Court

1728 29 January: *The Beggar's Opera* opens at Lincoln's Inn Fields Theatre
28 May: Hogarth succeeds in suing Morris for payment, Thornhill giving evidence on his behalf
Has at least three commissions in hand to paint conversation pieces

1729 23 March: marries Jane, only daughter of Sir James Thornhill

1730 January 31: has seventeen unfinished commissioned paintings in hand, mostly conversation pieces

1731 The Hogarths move into Thornhill's house, Great Piazza, Covent Garden

1732 April: painting of *A Harlot's Progress* series complete and engravings after it delivered to subscribers; Conduitt commissions *The Indian Emperor*

1733 Granted permission to paint the marriage of Anne, Princess Royal, but blocked by William Kent and Duke of Grafton
Settled at the Golden Head, Leicester Fields

1734 February: offers to paint staircase of St Bartholomew's Hospital staircase gratis
4 May: death of Sir James Thornhill
25 July: elected Governor of St Bartholomew's Hospital

1735 11 January: founding member of Beef Steak Club for actors, artists and theatre enthusiasts
15 May: Engravers' Copyright Act, prepared by Hogarth, receives Royal assent
26 June: painting of *The Rake's Progress* series completed and engravings after it delivered to subscribers
October: opens new St Martin's Lane Academy with Thornhill's equipment. Holds office of Steward to Grand Lodge of Freemasons for this year

1736 April: *The Pool of Bethesda* completed for St Bartholomew's Hospital

1737 July: *The Good Samaritan* completed for St Bartholomew's Hospital

1739 17 October: becomes Founding Governor of the Foundling Hospital

1740 May: presents *Captain Thomas Coram* to the Foundling Hospital

1742 February: praised in Fielding's *Joseph Andrews* as 'comic history-painter'

1743 May: in Paris to hire engravers for *Marriage A-la-Mode*

1745–6 The Jacobite Rebellion: Prince Charles Stuart attempts to invade Britain via Scotland

1746 Presents *Moses before Pharaoh's Daughter* to Foundling Hospital and gets other leading artists to follow suit

1747 5 November: first annual dinner of Foundling Hospital artists

1748 June: *Paul before Felix* for Lincoln's Inn finished
August: second trip to Paris ends with expulsion from Calais. Paints *The Gate of Calais* on return

1749 September: buys small country house at Chiswick
Works on *The March to Finchley*, possibly intended as a companion to *The Gate of Calais*, showing the British Army's response to the Jacobite invasion of Britain in 1746

1750 30 April: Foundling Hospital wins *The March to Finchley* in Lottery

1751 7 June: *Marriage A-la-Mode* paintings do badly at auction

1752 26 February: elected Governor of Bethlehem Hospital for advising on altarpiece

1753 Attempt by artists to set up new public academy to secede from St Martin's Lane Academy
November: *Analysis of Beauty*, Hogarth's only literary work, published; immediately translated into German

1755 Hogarth elected member of newly founded Society of Arts, and serves on committee for awarding prizes to young artists
Completes painting *Election* series
May: commissioned to paint altarpiece for St Mary Redcliffe, Bristol

1756 Bristol altarpiece transported from London and installed by July

1757 Leaves Society of Arts
24 February: announces in press that he will paint no more histories and will return to portrait painting
June: appointed to the sinecure post of Serjeant Painter to the King, in succession to his brother-in-law John Thornhill

1758 Autumn: accepts commission from Sir Richard Grosvenor to paint *Sigismunda*

1759 Warton publishes criticism on Hogarth
June: Grosvenor declines *Sigismunda*
Reynolds satirises Hogarth in *The Idler*

1760 April: first public exhibition of contemporary British art by Society of Artists. Hogarth does not participate
First signs of illness
25 October: death of George II and accession of George III (crowned following September)

1761 May: Society of Artists second exhibition includes seven paintings by Hogarth
15 December: elected to committee of Society of Artists
Italian edition of *Analysis of Beauty* published

1762 April–May: organises humorous Sign Painters' Exhibition with writer Bonnell Thornton to satirise rival Society of Arts
May: not represented in Society of Artists' exhibition
9 September: Hogarth's pro-government print in praise of Bute provokes abuse of Whig opposition party
25 September: Wilkes attacks Hogarth in the Whig periodical *North Briton*
October–November: serious illness

1763 30 June: the satirist Charles Churchill publishes attack on Hogarth as painter
July: paralytic seizure. Writing notes for an autobiography
16 August: publishes print attacking Churchill

1764 16 August: writes will
25/6 October: dies in Leicester Fields, aged 67
2 November: buried at St Nicholas, Chiswick

1789 13 November: death of Mrs Hogarth, aged 80

1790 24 April: sale of Mrs Hogarth's collection at Greenwood's, Leicester Square

1 The Painter and his Pug 1745

Oil on canvas 90 × 69.9 (35⁷⁄₁₆ × 27½)
Inscribed 'The LINE OF BEAUTY/ And GRACE/ W.H. 1745'
on palette bottom left, and 'SHAKE/SPEARE', 'SWIFT/
WORKS' and 'MILTON/ PARAD/ LOST' on spine of books,
top to bottom
Tate Gallery N00112

Hogarth's famous self-portrait developed over many years in as
radical a manner as the painter's own career. It began life in the
mid-1730s as the gentlemanly image of an artist who was
primaily an engraver and had done well out of it. X-rays of the
painting (fig.9) confirm that the portrait on the then much
smaller false oval canvas coincides in every particular with that
of a miniature (fig.10), probably by Hogarth's friend André
Rouquet, which was clearly made after it. It represents a suc-
cessful artist in an expensive wig, sporting gold buttons on his
formal coat and waistcoat. The palette is already in the bottom
left corner of the picture, its thumb-hole filled with a bunch of
brushes. Above it, however, and much more prominent, is the
shiny knob of a large graver that held pride of place on top of
the pile of books, directly in front of the artist. It is a safe bet
that Trump, Hogarth's favourite pug, was not yet there to dis-
turb accepted conventions of formality.

Over the coming years Hogarth came to see himself in an
increasingly different light. On his trip to Paris in 1743 he must
have been struck by the high social status and self-confidence
of the artistic community there, and he too began to prefer an
artistic image of himself above a gentlemanly one. The portrait
was re-worked to show him in artistic undress, supported by
volumes of Shakespeare, Milton and Swift, to show that his
inspiration was based on drama, epic poetry and contemporary
satire. The conventional brushes were removed from the
palette, which now supported the Line of Beauty and Grace,
the gently curving line which Hogarth considered to be the
basis of all that was harmonious and beautiful. These intellec-
tual symbols are balanced on either side by Trump, one of a
succession of much-loved pugs, almost certainly representing
the unadorned truth of Nature which Hogarth also studied
avidly, as well as the alter ego of the 'pugnacious' artist him-
self. The graving tool has disappeared, and Hogarth the
engraver and painter has been transformed into Hogarth the
painter and thinker.

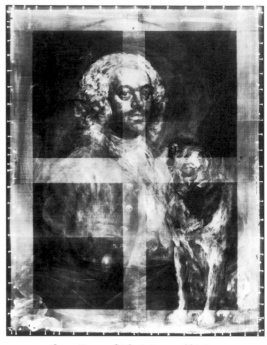

fig.9 X-ray of *The Painter and his Pug*

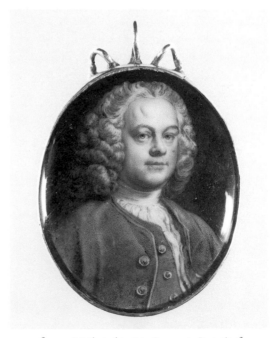

fig.10 Attributed to J.A. Rouquet, *Portrait of
William Hogarth* c.1735, enamel miniature 4.5 × 3.7 cm
National Portrait Gallery, London

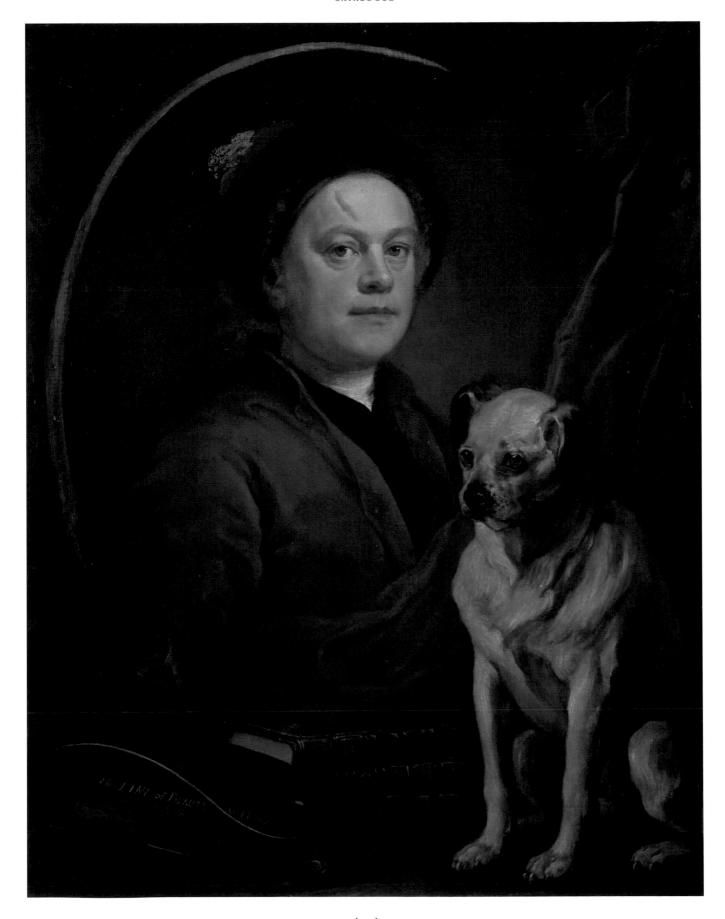

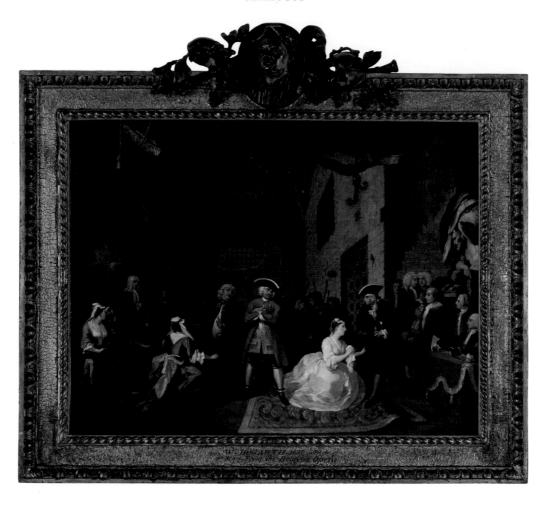

2 A Scene from *The Beggar's Opera* VI 1731

Oil on canvas 57.2 × 76.2 (22½ × 30)
Inscribed 'VELUTI IN SPECULUM' and 'UTILE DULCI' top
centre, on ribbon on either side of the coat of arms
Tate Gallery NO2437

John Gay's *The Beggar's Opera*, produced by the impresario John
Rich at the Lincoln's Inn Fields Theatre in 1728, was the great
musical hit of its age. It shattered the hitherto prevailing oper-
atic tradition of gods and godesses in fantastical dress singing
grand Italian arias by setting the action in the criminal under-
world of the day, where actors in modern dress played recog-
nisable characters and sang airs based on popular street ballads.
For Hogarth, who had a lifelong fascination for the theatre, it
provided the trigger for his first serious exercise as a painter
and set the keynote for his chosen role as a painter of 'modern
moral subjects', a story-telling genre hitherto associated almost
exclusively with cheap prints. He was to paint at least five ver-
sions of this scene, two of them for Rich. This is the last and
most developed of them. The Latin inscriptions declare that the
picture, like the play, is meant to hold up a mirror to society
and stress the moral usefulness of doing so.

Like the opera itself, the picture broke new ground: it is
thought to be the first painting ever made of an actual English
stage performance, and it was certainly the first where members
of the audience, crowded onto the stage as was then the cus-
tom, were shown as active participants in the event. Each suc-
cessive version gained in confidence and elaboration, until in
the last two Hogarth included an important sub-plot that grew
out of the performance itself and which added greatly to the
play's notoriety. The Duke of Bolton (wearing the Garter star,
seated on the right) is shown looking transfixed at the young
actress Lavinia Fenton (see no.15), dressed in white, whose
exquisite singing of the part of the heroine Polly Peachum had
shot her to stardom. The Duke, twice her age and married,
attended every performance, and at the end of the opera's
unprecedented sixty-four night run Lavinia retired from the
stage to become his mistress, and eventually Duchess of
Bolton. This was the theatre of life itself, tailor-made for
Hogarth's satirical powers of observation, and something he
was to use as a prime source for his art for the rest of his
career. Above all, it translated with ease into the fast-selling
popular engravings that were to bring him fame and fortune.

The original frame is surmounted by a carved portrait
medallion of John Gay, and was probably made for the first
owner of the picture, Hogarth's friend the writer William
Huggins.

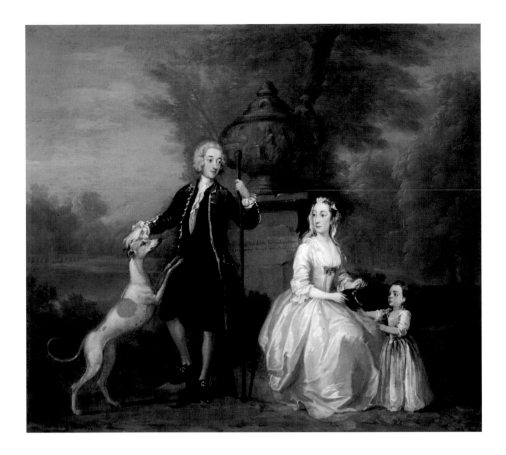

3 Ashley Cowper with his Wife and Daughter
1731

Oil on canvas 53.3 × 61.2 (21 × 24 1/16)
Inscribed 'W Hogarth Fecit/1731' bottom left and 'Hic gelidi Föntes, hic mollia prata – /Hic nemus, hic ipso tecum Consumerer/aevo.' on pedestal
Tate Gallery T00809

The quotation on the pedestal from Virgil's *Eclogues*, in which a shepherd promises to give up his hunting hounds to become a pilgrim in Arcadia in order to be with his beloved, sets the tone for this delightful picture of newly-wed bliss. As in *The Beggar's Opera* (no.2), on which Hogarth was working at about the same time, the portraits are good likenesses, but the sitters are performing parts in their own private play. Ashley Cowper, who is said to have been a good friend of Hogarth's, was a barrister and civil servant who married Dorothy Oakes in around 1730. Not too seriously, the young couple act out Virgil's poem, with Ashley leaning on a pilgrim's staff, his hunting cap abandoned beneath the sacrificial scene on the urn, patting his hound goodbye. In the poem the swain pleads that his beloved should listen to his song, and in this picture Mrs Cowper's attitude shows clearly that his song is not falling on deaf ears.

This is one of sixteen commissions Hogarth listed as having in hand in January 1731, which proves that by this time he was not short of orders, but was rather slow in executing them to his satisfaction. About three years later, when the Cowpers' first child Theodora was a toddler, Hogarth added her to the composition, wielding a by now smoother, more loaded brush. The difference in technique is clearly visible.

4 A Performance of *The Indian Emperor or The Conquest of Mexico* 1732–5

Oil on canvas 131 × 146.7 (51⅜ × 57¾)
Private Collection

This is not only the most important painting of Hogarth's early career, but one that brings together a surprising number of strands of British life and culture representative of the early Georgian era.

In the first instance the painting commemorates a private performance in the house of John Conduitt (1688–1737) of Dryden's *The Indian Emperor or the Conquest of Mexico by the Spaniards*, recently revived at Drury Lane. Conduitt had married Catherine Barton, favourite niece of Sir Isaac Newton, and had also succeeded the great man as Master of the Mint, a position which enabled him to move in the highest circles. The performers are Conduitt's little daughter Catherine (extreme right, in dark blue) and some of her titled playmates. It was an extremely lavish occasion, with scenery borrowed from Drury Lane and coaching from the theatre's manager Theophilus Cibber. The guests of honour were the royal children, seen here in their special box below the mantlepiece. Various nobles and their children make up the rest of the audience, while the host and hostess are modestly present only as portraits. Such was the success of the occasion, that a repeat performance was requested for the king and queen at St James's Palace.

Even more interesting, however, is the secondary programme of the picture, no doubt supplied by Conduitt himself. It amounts to nothing less than a ringing statement of the pre-eminence of the nobility of genius, proclaimed by the unequiv-ocally dominant position of the bust (probably by Roubiliac or Rysbrack) of the recently deceased Newton. Below him in the mantlepiece is the representation of a relief, designed by Conduitt and executed by Rysbrack, emblematic of Newton's scientific and administrative achievements, which was just being installed on Newton's tomb in Westminster Abbey. And acting as prompter in the wings is Dr John Theophilus Desaguliers, distinguished mathematician, friend of the family, disciple of Newton and enormousy influential 'behind the scenes' promoter of Freemasonry, the one institution where nobles and commoners could meet on an equal footing. At this stage Freemasonry was not particularly secretive, and both Hogarth and his father-in-law Sir James Thornhill (who had painted Newton's portrait more than once and through whom the commission probably came to Hogarth), as well most of the men present in the picture, were members.

Visually, this remains one of the grandest and most original conversation pieces in British art. The deep diagonal persepctive accomodates the required number of portraits in a lively and varied manner without strain, while the figures with their back to the viewer direct all the attention back onto the child actors. The natural movements of the members of the audience contrast with the formal gestures of the actors, and the lofty interior emphasises the grandeur of the occasion. A nice touch is the overmantel space behind the bust of Newton which corresponds to the dimensions of the painting itself and teasingly suggests its intended destination. Above all, Hogarth's masterly handling of paint, varying from rich impasto to shimmeringly descriptive line, discloses him as a mature and natural painter in oils.

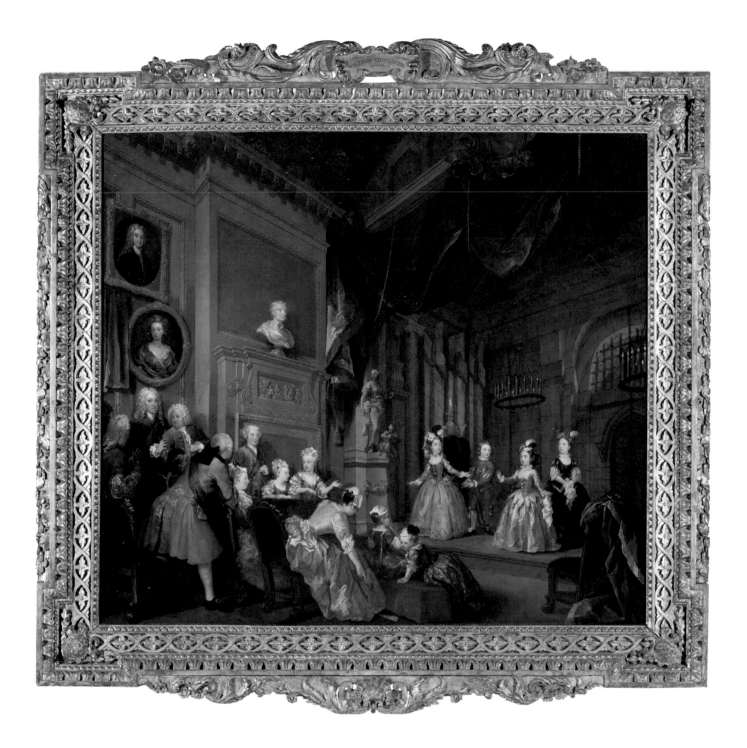

5 Satan, Sin and Death (A Scene from Milton's *Paradise Lost*) *c.*1735–40

Oil on canvas 61.9 × 74.5 (24⅜ × 29⅜)
Tate Gallery T00790

The subject illustrates a passage from Milton's *Paradise Lost* in which, during a violent confrontation at the Gate of Hell, the three embodiments of evil discover that they are all incestuously related to each other.

In the mid-1730s Hogarth attended a club of writers and artists at which the highly learned author and painter Johnathan Richardson discussed and read his recently published commentary on *Paradise Lost*. In it he singles out this scene as representing the key to the whole work. It may well have been this event that spurred Hogarth on to express the passage in paint. He knew the poem well and had engraved illustrations for it a decade earlier. More to the point, *Paradise Lost* is one of the volumes on which his great self-portrait (no.1) rests, proclaiming the fact that he took his inspiration not only from contemporary life, but also from sublime poetry. This fiery, impassioned sketch shows more clearly than anything Hogarth's early determination not to be pigeonholed as a painter of portraits and comic genre, but to be seen as a master of the grand epic style as well.

The picture surfaces first in the collection of David Garrick, and is said to have been painted for him. As an actor who covered the full range from comedy to tragedy, he would have understood well his friend's urge to range as widely in his own medium, as well as his need to rise to the challenge of trying to express the inexpressible.

Lit: D. Bindman, 'Hogarth's "Satan, Sin and Death" and its influence', *Burlington Magazine*, vol.112, 1970, pp.153–8

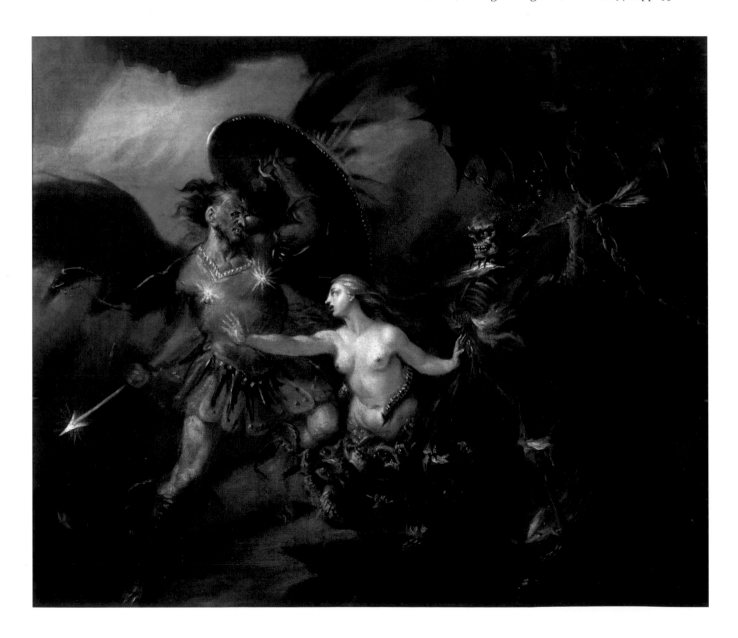

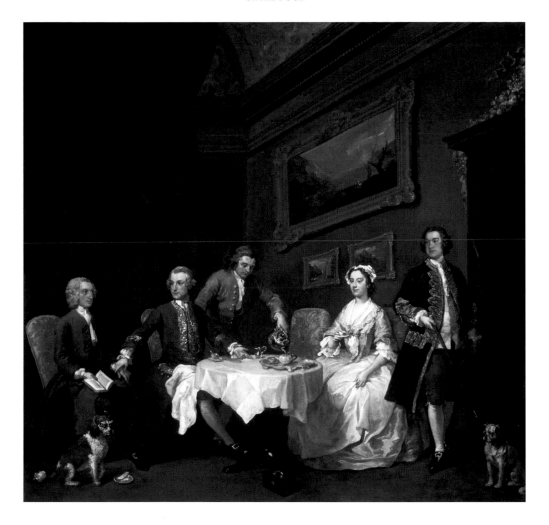

6 The Strode Family *c.*1738

Oil on canvas 87 × 91.5 (34¼ × 36)
Tate Gallery NO1153

The Strodes had made their fortune as South Sea brokers in the previous century. William Strode (*c.*1712–55), seated second from left, owner of Ponsbourne Hall, Herefordshire, and Member of Parliament for Reading by 1740, set the seal on their success by marrying into the aristocracy. His wife Lady Anne Cecil, here a vision in white lace and pale pink silk, was a sister of his friend the 6th Earl of Salisbury. This is a true 'lifestyle' picture, recording all the essentials of Strode's success and domestic happiness. He is flanked by his learned friend and tutor Dr Arthur Smyth, eventual Archbishop of Dublin, and by his contentedly tea-drinking wife, backed by his faithful butler Jonathan Powell, and fronted by exquisite – but not too modern – family silver and, on the floor, a caddy with precious tea. The lofty library speaks of his educated taste, as do the carefully hung typical Italian pictures (probably acquired during the Grand Tour he and Smyth had made a few years before), and the fashionable Rococo plasterwork decoration above the door. In most such scenes Hogarth liked to insert a touch of anarchy, usually through the medium of children or animals. Here William's brother Colonel Samuel Strode has had to leave his seat to restrain his pug, whose seemingly placid presence has aroused the snarling disapproval of the family poodle at his snack.

This is one of the best examples of the small-scale conversation pieces that brought Hogarth great success in his early career as a painter. He skilfully exploited the fashion for informal domestic family groups by emphasising, whenever he could, action – and indeed interaction – over pose, in a way not unrelated to his intimate knowledge of the modern theatre. As a result, his conversations have a sense of immediacy and liveliness unmatched by rivals. The Strode group also demonstrates the labour and artifice that went into such compositions: x-rays show innumerable repaintings of the figures and background, making it clear why Hogarth eventually gave up this form of portraiture as being too time-consuming and not lucrative enough. Sometimes Hogarth's small pictures have the appearance of being a battleground for testing pictorial effects: here, for instance, Hogarth made the late decision to cover the tea-table with a sparkling white cloth, which has the optical effect of pushing it further towards the eye and making the room appear deeper and more three-dimensional.

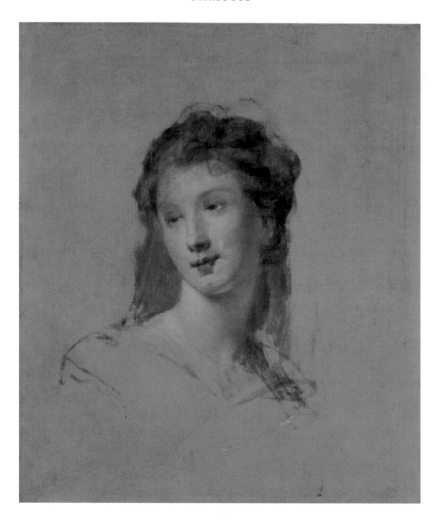

7 Head of a Lady, called Lady Pembroke
*c.*1735–40
Oil on canvas 62.8 × 53 (24¾ × 20⅞)
Tate Gallery T06870

8 The Shrimp Girl *c.*1750
Oil on canvas 63.5 × 52.7 (25 × 20¾)
Trustees of the National Gallery, London

These two sketches or unfinished works represent the two opposite extremes of Hogarth's approach to painting the female head. Neither of them need have been a portrait: the title 'Lady Pembroke' is traditional, and we do not know if Hogarth used a model for his 'shrimp girl', or simply relied on his memory for 'characters'. In any case, an expression as fleeting as that of the shrimp girl would have been impossible to pose. Works such as this are very difficult to date, but one can surmise that the more cautious *Head of a Lady* is earlier than the bold and free handling of *The Shrimp Girl*. Both are painted on the typical buff ground on which Hogarth would sketch his first ideas in grey paint and then start building up areas of light and dark and of colour. What is clear is that the *Head of a Lady* is an attempt to represent ideal female beauty rather than real character, and it may have even been a sketch for some unknown larger composition in the classical manner, rather like the lost sketches that are known to have existed for *Moses before Pharaoh's Daughter* (fig.4). *The Shrimp Girl*, on the other hand, is a low-life genre piece of the kind popular in the eighteenth century throughout Europe, which aimed to express the untrammelled vitality of street life and the charm of everyday activities. Both pictures would have looked very different if brought to completion, losing the ethereal transparency and impressionistic freedom for which they are valued today. As it is, they remained among the unfinished works in Hogarth's studio and can now provide a remarkable insight into his working methods.

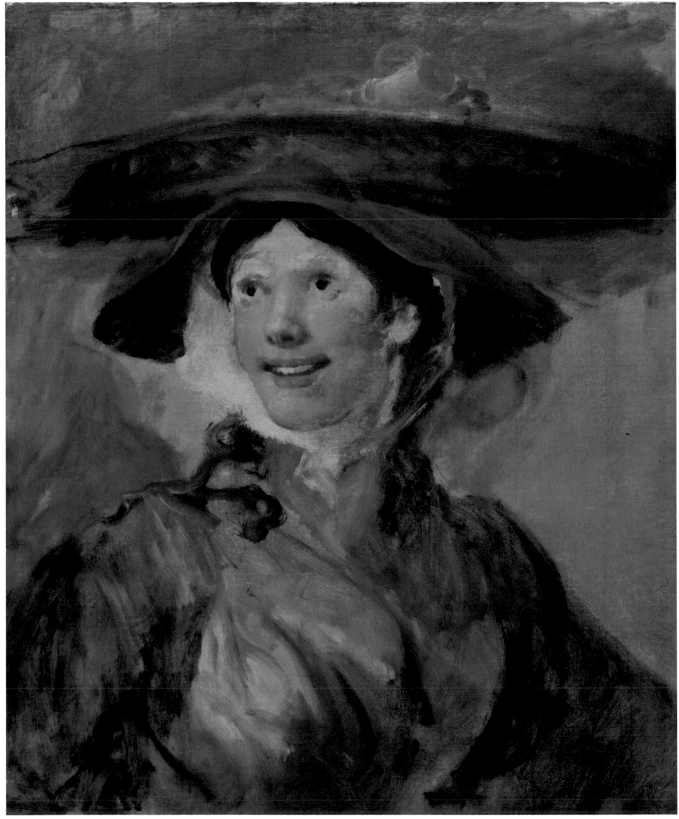

8

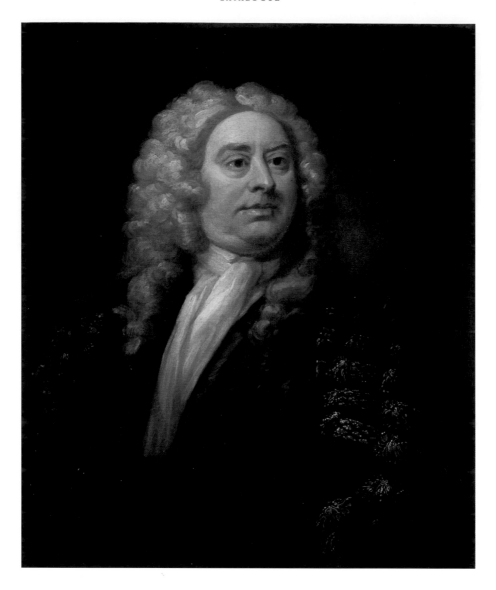

9 Thomas Pellett MD *c.*1738–9

Oil on canvas 76.4 × 63.5 (30⅛ × 25)
Signed 'W Hogarth' in upper right spandrel and inscribed
with the name of the sitter
Tate Gallery T01570

Dr Pellett (?1671–1744) wears the robes of President of the
Royal College of Physicians, a position he held from 1735 until
1739. The portrait, which was engraved by John Faber in 1739,
presumably celebrates his term of office. The sitter was a suc-
cessful physician with wide interests and a friend and travelling
companion of the most famous physician of his day, the art
loving Dr Richard Mead. Pellett was also something of an
enthusiast for Hogarth: the sale of his enormous library of
scientific and classical books after his death included an almost
complete collection of Hogarth's engraved works to date. That
they also shared other tastes can be deduced from another item
in the sale, a sumptuously bound copy of the text and music of
The Beggar's Opera, the subject of Hogarth's first great success in
painting (no.2).

The medical profession flocked to Hogarth for their por-
traits, with the notable exception of Dr Mead, who preferred
the reliably fashionable elegance of Ramsay. On the strength of
this portrait, Mead could be forgiven for thinking Hogarth a
somewhat old-fashioned representative of the Kneller tradition
of the previous generation – in fact, the picture spent most of
the nineteenth century miscatalogued as a Kneller. Hogarth,
who greatly admired Kneller, would have regarded this as a
compliment. Indeed it is quite possibly an attempt to echo
Kneller's bust portrait of Sir Isaac Newton (now in the Nation-
al Portrait Gallery) which Hogarth would have known at first
hand when it was still in the Conduitt collection (see no.4) and
which would have represented for him the model of an official
portrait of a man of science.

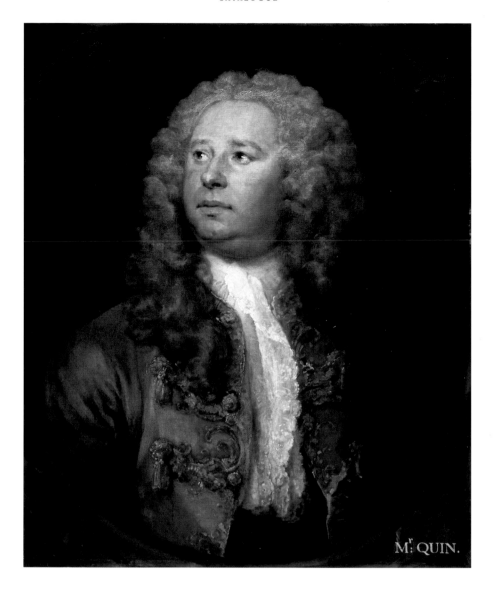

10 James Quin, Actor *c.*1739

Oil on canvas 76 × 62.2 (29⅞ × 24½)
Illegibly signed and dated bottom left
Tate Gallery NO1935

James Quin (1693–1766), the leading tragic actor of the pre-Garrick era, is portrayed here at the height of his powers, but already showing the results of his proverbial greed at table. The heroic turn of the head recalls the earlier style of Kneller and is entirely appropriate for a representative of the old school of static and declamatory acting who had been playing leading roles since 1716. He was for some years a rival of David Garrick (no.29), the rising star of the new naturalistic style, but after Quin retired from the stage in 1751 they became good friends.

Hogarth was friendly with both actors, and his portraits of them reflect in each case their particular approach to acting – slightly bombastic and strutting (even in a bust portrait) for Quin, mobile and active for Garrick. Here Hogarth differs, however, from earlier painters like Kneller in not allowing either the wig or the flamboyant costume to overwhelm the sitter's character. 'The full-bottom wig, like the lion's mane, hath something noble in it', he wrote, '… but were it to be worn as large again, it would become a burlesque'. Hogarth's ability to handle flesh-tones and the trick of concentrating more light on the face – especially the forehead – lets the wig recede into the dark background like an almost irrelevant accessory and makes the head bulge forward with energetic and expressive life.

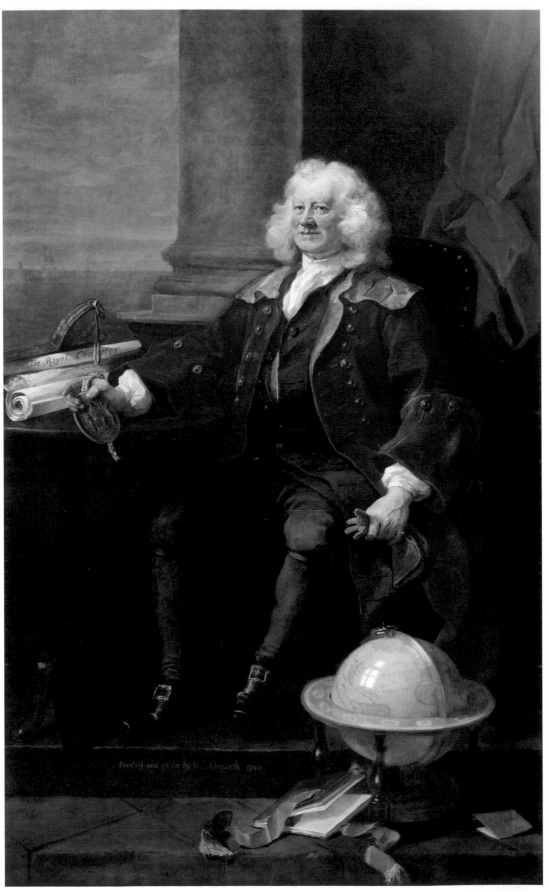

II

11 Captain Thomas Coram 1740

Oil on canvas 239.4 × 149.2 (94¼ × 58¾)
Inscribed W.Hogarth Pinx! 1740' lower left
Thomas Coram Foundation for Children

This portrait marks a milestone in British art. It breaks with tradition by presenting a sitter of undisguised humble origins on a scale and in a grandiose manner hitherto reserved for nobles and statesmen, and it proves, as Hogarth intended it to do, that prevailing conventions were mere tools to be used by an artist as he saw fit.

Thomas Coram (*c.*1668–1751) made a fortune in shipbuilding in America and Rotherhithe. He was from early days a dogged and tireless fighter for difficult causes, and after retiring from business in 1719, he devoted the rest of his life to charitable works. The most important among these was the granting of a royal charter for a Foundling Hospital, achieved in 1739 after seventeen years of ceaseless lobbying of the great and the rich. Neglectful in the end of his own affairs, Coram died poor, if respected. But the Foundling Hospital caught the public imagination and its grand public rooms became a meeting place for society. Well aware of the promotional value of having important works hanging in a well-attended public institution, Hogarth donated this picture to the fledgling charity in 1740; he also got other artists to follow suit, with the result that to this day the collection remains a showcase of British art and taste in the 1740s.

Yet the tension set up by the unconventional coupling of the Grand Style with unvarnished truthfulness of characterisation was such that, even though greatly admired, the picture failed to generate similar commissions. The smooth world of fashion was, not surprisingly, mistrustful of the probing brush of a painter already famous for ridiculing its foibles in paint. It remains Hogarth's only straight full-length portrait 'as big as the life'.

At the end of his life, when jotting down notes for an autobiography, Hogarth looked back proudly upon this work as having stood the test of twenty years among 'all the first portrait painters in the Kingdom' (i.e. other full-lengths in the Coram collection by Hudson, Ramsay, Shackleton, Reynolds and the now little-known Benjamin Wilson). Typically, his sense of satisfaction was all the greater because he felt that he had achieved this without being a specialist in the branch of portrait painting.

12 George Parker, 2nd Earl of Macclesfield
*c.*1740

Oil on canvas 127 × 102 (50 × 40⅛)
The Earl of Macclesfield

George Parker, 2nd Earl of Macclesfield (*c.*1697–1764), was a remarkable scholar, astronomer and mathematician, a Fellow and later President of the Royal Society, and for many years Vice-President of the Governors of the Foundling Hospital (see no.11). He built a splendid private observatory and a large chemical laboratory at Shirburn Castle, his Oxfordshire home, and assembled one of the great science libraries of the time. In Parliament he was chiefly responsible for the bill which introduced in 1752 the 'New Style' Gregorian calendar in Britain, thus synchronising it with the rest of Europe.

Lord Macclesfield's alert pose and expression, and the speaking gesture of his right hand, show him engaged in scholarly disputation, perhaps with his friend and fellow-mathematician William Jones (no.13), whose portrait was painted to match this. The colonnade in the background is a device not met with elsewhere in Hogarth's portraits and could be an allusion to the colonnades of the classical Greek stoa or palaestra, a public place 'where philosophers, rhetoricians and others who delight in learning may sit and converse', according to the writings on architecture of Vitruvius (book V, chapter XI), the bible on correct taste to all educated men. At the same time, avoiding any false modesty, the earl's noble status is affirmed by the coronet on the back of his chair and by the rich setting. Above all, Hogarth has been allowed to revel in the sheer magnificence of his brocaded silk waistcoat of recent English manufacture and brown cut and uncut velvet coat, amply demonstrating the painter's ability to deal with the outer as well as the inner man.

The compiler is most grateful to Natalie Rothstein for information on the costume.

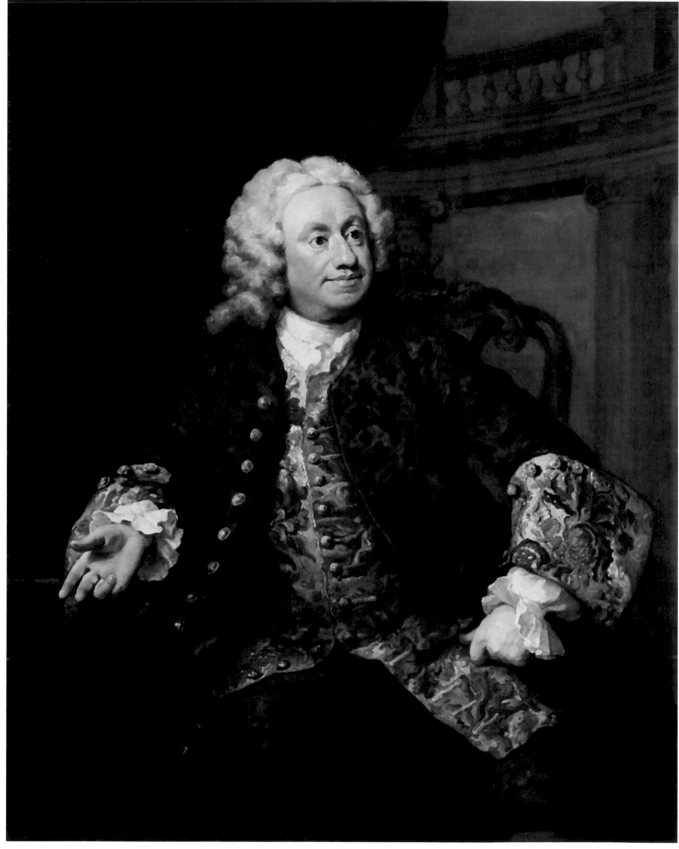

12

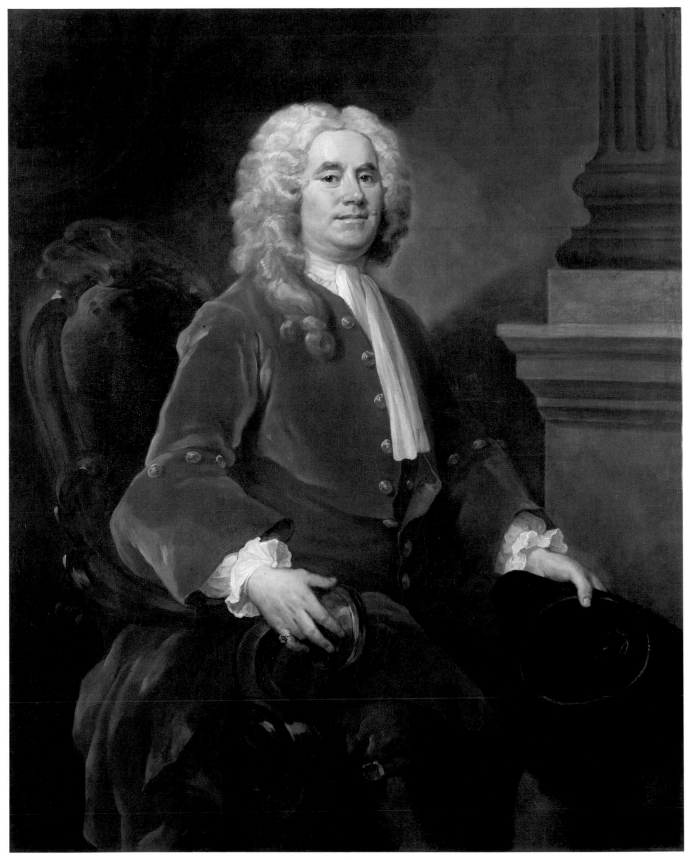

13

13 William Jones 1740

Oil on canvas 127 × 102.2 (50 × 40¼)
Signed 'Wᵐ Hogarth Pinxᵗ 1740' bottom right corner, and
inscribed 'Wᵐ Jones Esqʳ' on base of column
National Portrait Gallery, London

William Jones (1675–1749), was one of the most outstanding mathematicians of his day. The son of a modest Welsh farmer, his gifts were recognised early and he received a good education. He collaborated with Newton and Halley, was elected Fellow of the Royal Society in 1712, and became its Vice-President in 1737. In 1711 he edited Newton's works to the great man's satisfaction, and he was writing an ambitious introduction to Newtonian philosophy when he died. He bequeathed the manuscript to his friend and patron Lord Macclesfield (no.12) for completion, together with his notable scientific library, but the project was never finished and the library was sold in 1801.

Jones was mathematics tutor to both the 1st and 2nd Earls of Macclesfield, and he and his family lived for most of his life at Shirburn Castle, the Macclesfield seat, as guests and companions of both father and son. This close relationship is expressed in the companion portraits of Jones and the 2nd Earl commissioned from Hogarth in around 1740. That of Jones is arguably one of the most sympathetic large-scale portraits ever painted by Hogarth apart from Coram (no.11). If Lord Macclesfield's portrait is given all the flamboyance, that of Jones exudes a quiet dignity that has its own sub-text: the pose, composition and colour scheme are taken directly from John Vanderbank's 1725 portrait of Sir Isaac Newton at the Royal Society, only here the same ingredients have been translated by a greater artist into an infinitely more powerful image.

14 Benjamin Hoadly, Bishop of Winchester 1741

Oil on canvas 127.3 × 101.5 (50⅛ × 40)
Signed along back of chair 'W.Hogarth Pinx 1741'
Tate Gallery NO2736

Benjamin Hoadly (1676–1761) is shown here in his robes of office as Bishop of Winchester and Prelate of the Order of the Garter, the culmination of his hugely distinguished, not to say lucrative, career in the church. His left hand is raised, palm down, in a teaching gesture made against the background of a church window with an angel bearing the arms of Winchester, and with the figure of St Paul. The latter reflects Hoadly's role as the leading protagonist of Pauline theology, which represented the 'low church' stream of Anglicanism that placed, crudely put, good acts above blind faith. The gesture probably echoes that of Aristotle in Raphael's celebrated *School of Athens*, one of the most discussed paintings of the time, to indicate the Aristotelian roots of this philosophy. The programmatic nature of this portrait is reinforced by its original customised frame, embellished with appropriate episcopal symbols and even substituting the shell of St James, the emblem of Christian pilgrimage, for the usual egg-and-dart moulding.

Inspite of being crippled from youth, Hoadly led an active and far from abstemious life. He entertained lavishly not only politicians, but also actors and artists (his first wife had been a professional painter before her marriage), loved the theatre, and obtained well-paid posts for his sons. Hogarth was friendly with the whole family and painted most of its members, some of them more than once. This is one of Hogarth's finest portraits, painted with sparkling freedom and evident affection, yet completely devoid of flattery.

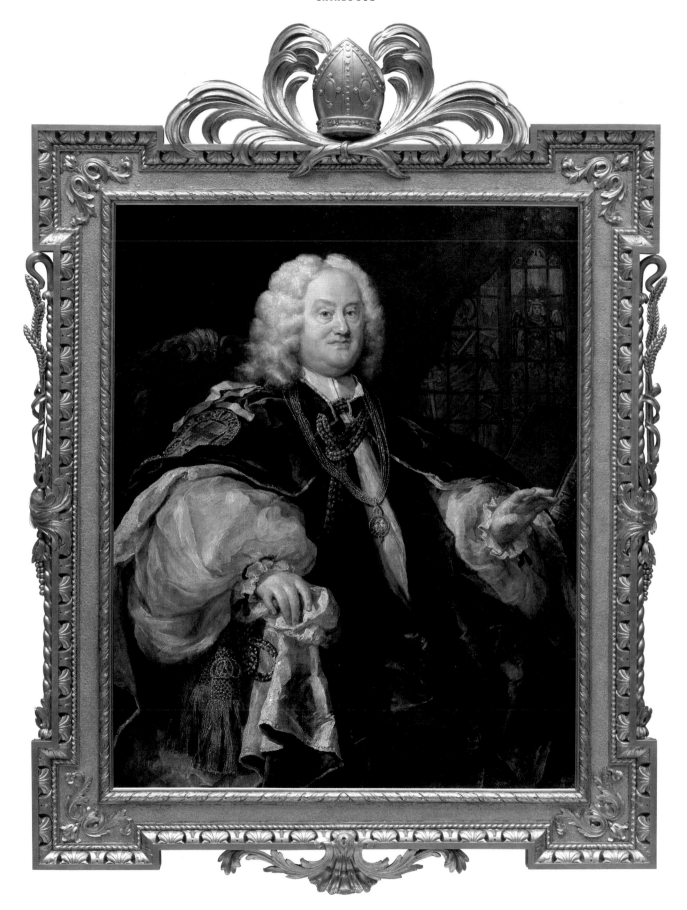

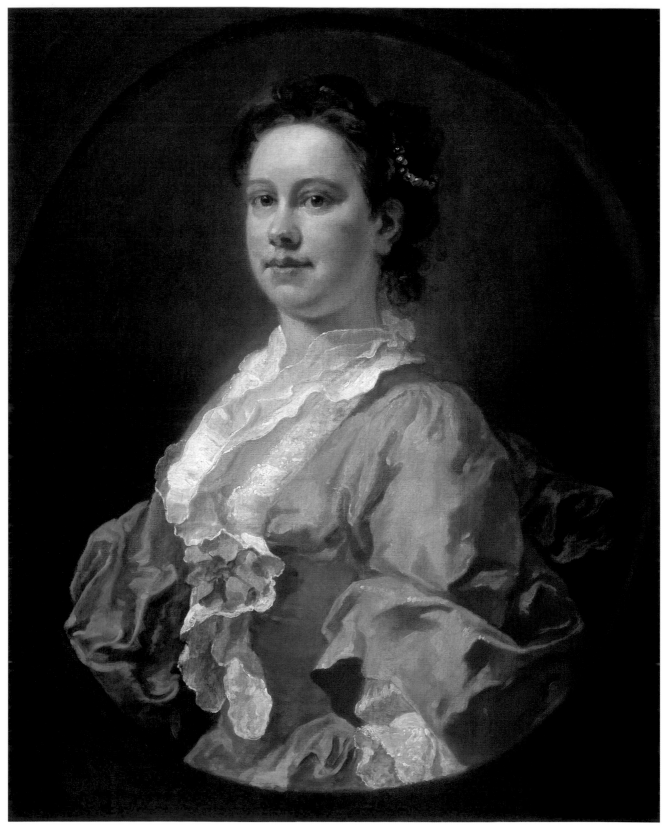

15

15 Mrs Salter 1741

Oil on canvas 76.2 × 63.5 (30 × 25)
Signed 'W Hogarth/Pinx! 1741' and inscribed 'Mrs. Salter'
bottom centre on stone surround, in same hand
Tate Gallery NO1663

Elizabeth Secker (1720–after 1778) was the wife of the Revd
Dr Samuel Salter, tutor to Philip Yorke, 2nd Earl of Hardwicke,
and later Master of the Charterhouse Pensioners' Hospital.
New regulations allowed married men to occupy the post, so
that 'Mrs. Salter of the Charterhouse', as she became known,
was the first woman to live there since its foundation in 1611.
Both Lord Hardwicke, and his father the 1st Earl, were tutored
in mathematics by William Jones (no.13), and were intimate
friends of the 2nd Earl of Macclesfield (no.12).

This wonderfully spirited and richly coloured work was
long thought to have been inspired by contemporary French
portraits that Hogarth had seen during his trip to Paris in May
1743. Recent cleaning, however, confirms the date as 1741, and
shows that Hogarth was fully conversant with the modern
Rococo style well before his tour abroad.

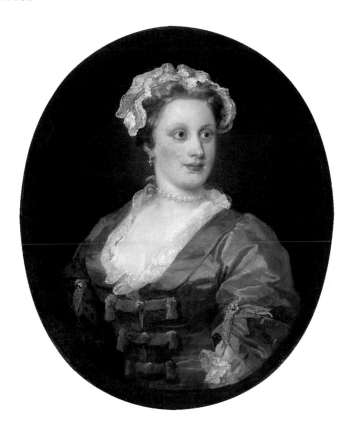

16 Lavinia Fenton, Duchess of Bolton c.1740–50

Oil on canvas 76.2 × 62.8 (30 × 24¾)
Tate Gallery NO1161

This is traditionally thought to be a portrait of Lavinia Fenton
(1708–60), the heroine of *The Beggar's Opera* (no.2), painted
some time before she became Duchess of Bolton in 1751, when
the death of the Duke's estranged first wife left him free to
marry Lavinia. It certainly does not show her, as has sometimes
been claimed, in the part of Polly Peachum which she made
famous, since the rich apparel here is nothing like Polly's plain
dress that was meant to affect 'the simplicity of a quaker'. If it
is Lavinia, this would represent her in her riper years, probably
after she had borne the duke three illegitimate sons, all of
whom made successful careers in the army, navy and church. In
her role as the Duke's mistress she is said to have been an
accomplished and delightful companion, and a model of dis-
cretion.

This is one of Hogarth's most heavily reworked portraits;
only the face appears to have been left unchanged. X-rays
show that she originally wore not a sensible cap but a hair
ornament of some sort with a tuft of feathers, and an undress
gown; both hands were visible and steadied a basket of flowers
in the left foreground. The portrait was originally set in the
usual false oval within a rectangular canvas, but this was cut
down to the present oval, probably sometime in the nineteenth
century. The paint surface has also suffered in the past and it is
probable that the dark shadows around her eyes would have
been less apparent under the original glazes.

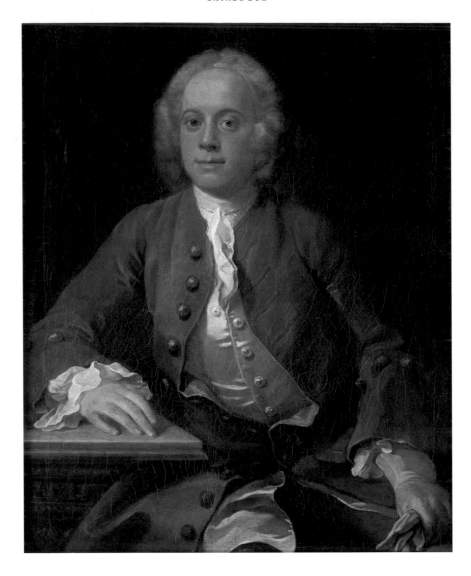

17 Unknown Gentleman in Grey, Holding Gloves c.1740

Oil on canvas 84.5 × 68.5 (33¼ × 27)
Private Collection

This portrait was unknown before 1989 and has not been exhibited until now. Its size, and the format of a seated knee-length figure with both hands showing, is rare in Hogarth's work. Its similarity to the portraits of the London merchant George Arnold (1683–1766) and his daughter Frances (born 1721, date of death unknown), now in the Fitzwilliam Museum, Cambridge, has been rightly noted. The Arnolds are said to have been painted at their country seat, Ashby Lodge,

Northamptonshire, an area where a number of Hogarth's friends and sitters, like the Palmers of Ecton, are known to have resided. The Arnold portraits, like this one, are neither signed nor dated, but have been plausibly dated to around 1740, or a little later, on stylistic grounds.

In the absence of any other evidence it might be conjectured that this is the portrait of George Arnold's son and heir, Lumley Arnold (1723–1781), barrister at law, which could at some time have moved into another branch of the family, away from the other two pictures. The three pictures would have certainly hung together harmoniously, and the old man might have found it comforting to be thus flanked by his two favourite children after the death of his wife Anne in 1741.

18 The Graham Children 1742

Oil on canvas 160.5 × 181 (63¼ × 71¼)
Signed 'W Hogarth/Pinxt 1742' bottom right
Trustees of the National Gallery, London

This group of the children of Daniel Graham (1695–1778), apothecary to the royal household and the Chelsea Hospital, is one of the masterpieces of Rococo painting in Britain. Graham's eldest daughter Henrietta stands on the left, wearing a blue dress, his son and heir Richard is seated on the right, playing the bird-organ or serinette, while Anna Maria, in a flowered dress, stands between them. Henrietta holds by the hand baby Thomas, who is seated in a gilded carriage beside a ravishingly painted still-life of fruit in a silver basket. It is a sobering thought that Thomas died in February 1742, and that this is in all probability a posthumous portrait of him. Henrietta married her cousin Daniel Malthus in 1752 and became the mother of the famous philosopher and economist Thomas Robert Malthus (1766–1834). Anna Maria and Richard also married well and led predictably comfortable lives.

The children are surrounded by time-honoured symbols of the passing of time and the transient state of childhood and innocence, and the unusually grand scale of the painting is thought to echo Van Dyck's famous portrait group of the children of Charles I in the Royal Collection. What is new is the skill and ingenuity with which Hogarth has woven these details into the children's natural surroundings so that they look neither forced nor heavily didactic. The children's actions are suited to their respective ages, be it the responsible dignity of the eldest girl, Richard's fascination with his mechanical toy, Anna Maria's joyful dance, or the baby's concentration on food. All testify to Hogarth's ability to depict realistic life, noise and movement, as well as the more cruel aspects of nature, like the terrified goldfinch fluttering in its cage, aware of being the object of the concentrated greed and fascination of one of the best painted cats in eighteenth-century art.

Lit: M. Webster, 'An Eighteenth-century Family', *Apollo*, vol.130, September 1989, pp.171–3

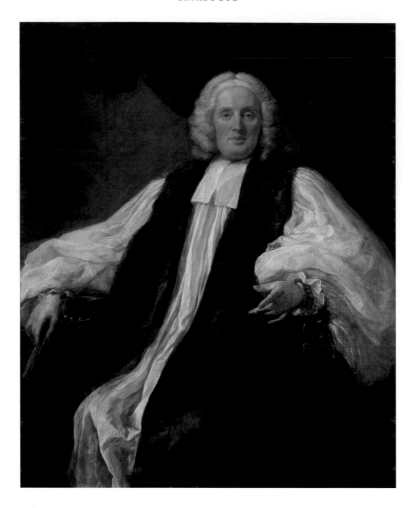

19 Thomas Herring, Archbishop of Canterbury
1744–7

Oil on canvas 127 × 101.5 (50 × 40)
Signed twice 'W.Hogarth pinx! 1744' centre left above
hand, and 'Hogarth pinx./1747' bottom left; inscribed
'Thomas Herring. Archbishop of Canterbury 1747' top
right
Tate Gallery T01971

The portrait was begun in 1744, when Thomas Herring
(1693–1757) was Archbishop of York, a post he held until his
promotion to the see of Canterbury in 1747. He was one of
Hogarth's most elevated sitters, and the painter seems to have
been acutely aware of this. 'The crown of my works will be the
representation of your Grace', Hogarth is reported to have told
him during sittings, and to have suggested that the portrait
would rank with the best works of Van Dyck and Kneller.
However, not surprisingly in view of Hogarth's trip to France
the previous year, it is the the influence of French models that
is most noticeable here, and the composition bears a distinct
family resemblance to many portraits of grandees cast in the
Baroque mould by Van Loo, Largillière, Rigaud, de La Tour
and others. Unlike the portrait of Bishop Hoadly (no.14) com-
pleted three years before, Hogarth endeavours to attain here

the grandeur of simplicity, letting style rule over character, and
eschewing any 'business' of detail that might detract from the
magisterial gesture of the hand and the dominating vitality of
expression. Originally the archbishop was backed by a classical
column on the left, but this was painted out, leaving Hogarth's
first signature, which fitted neatly into its base, suspended in
mid-air above the sitter's right hand.

Unhappily, the likeness failed to please, and in 1747, when
Herring was translated from York to Lambeth Palace, Hogarth
had another go at it. The alterations were drastic enough to
warrant another signature, and may have involved repainting
the head entirely, as well as lowering the arm-rests and reduc-
ing the width of the figure. If Hogarth felt any sense of frustra-
tion or rage when doing this, it was expressed in some of his
most extraordinarily free and broad brushwork, particularly in
the lawn sleeve on the right. Be that as it may, the contrast
with Hoadly is remarkable, both technically and in approach,
as one portrait is clearly driven by affection, the other by ambi-
tion. Given that one prelate adored the theatre and numbered
actors among his best friends, and the other had famously con-
demned *The Beggar's Opera* (no.2) from the pulpit as 'a thing of
very evil tendency', it is obvious with whom Hogarth's true
affinities would have lain.

20 Mrs Desaguliers *c.*1745

Oil on canvas, diam. 68.5 (27)
Private Collection

Mary Blackwood was the wife of Major-General Thomas Desaguliers (1721–80), Chief Firemaster of Woolwich Arsenal and younger son of the Dr Desaguliers who appears in *The Indian Emperor* (no.4). The fact that one of his godparents was Thomas Parker, 1st Earl of Macclesfield, father of George (no.12), while Newton himself stood sponsor to his younger brother John Isaac, shows how tightly knit the scientific community, centred on the Royal Society, was in the early eighteenth century, and how closely Hogarth was involved with it. Traditionally this portrait is thought to date from 1741, but stylistically it could be later, and it is unlikely to have been painted before the sitter's marriage in 1745. Unfortunately Mary's dates are unknown, except that she was probably under age when she married, since by tradition 'she ran away with him from Ranelagh', and that she died sometime before 1753.

The picture is particularly interesting in the deliberate way in which it invites comparison with older masters like Van Dyck and Lely, as if to refute the criticism, angrily recalled by Hogarth in his autobiographical notes, that he could not paint dignified portraits of women. This is Hogarth's interpretation of the Grand Style, and it is entirely successful. It makes much of the lustrous silks and pearls of the historicising costume, while the sitter's regal pose is emphasised by the unusual circular format. At the same time the delicious Rococo flutter of the bow at her throat and the hint of a smile in the strong face leave one in no doubt that she is not a fashion-plate, but a modern, lively, perhaps even wilful, personality.

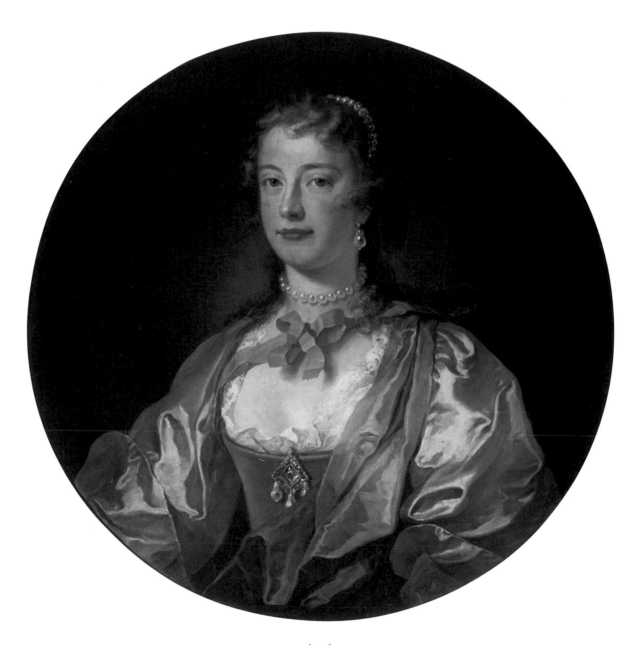

21 The Staymaker (The Happy Marriage V: The Fitting of the Ball Gown) c.1745

Oil on canvas 69.9 × 90.8 (27½ × 35¾)
Tate Gallery NO5359

22 The Dance (The Happy Marriage VI: The Country Dance) c.1745

Oil on canvas 67.7 × 89.2 (26⅝ × 35⅛)
Tate Gallery T03613

These are two sketches for the series *The Happy Marriage* which Hogarth planned in the mid-1740s as a companion set to the *Marriage A-la-Mode* (National Gallery), but which was never completed. It was to contrast the immoral goings-on in London's fashionable society with the old-fashioned virtues of life in the country. *The Staymaker* shows the wife being fitted for a gown she will wear at the first dance to be given by her husband at the old mansion after inheriting the estate from his much-loved father. The scene is set in the nursery, where the young couple are surrounded by their brood of healthy and mischievous children and busy domestics. In the finale of the series, *The Dance*, the ball is in full swing, celebrating the successful handing over of a well-run estate from one generation to the next.

The unfinished state of the pictures fully reveals the freedom and panache of which Hogarth's brush is capable. *The Staymaker* shows that he has looked at contemporary French engravings, for the group on the left is a free adaptation of an elegant fashion print by C.N. Cochin of 1737. The vignette of the father lounging on the settee in his housecoat, besotted with his newborn, while the old nurse kisses its bottom, is, however, pure Hogarth. Similarly, the participants in *The Dance* represent the whole gamut of characters from the elegant couple on the right, presumably the host and hostess, to the comic country bumpkins further down the line. Their movements, enhanced by the rapid technique and lack of finish, illustrate Hogarth's not entirely original theory that essential beauty is represented by gracefully curved lines, and ugliness by stiff and angular ones. Indeed Hogarth was to adapt this composition later for one of the two didactic prints that illustrate his only theoretical work on painting, *The Analysis of Beauty*, published in 1753. In the other print he uses the evolution of a well-made stay to illustrate the same principle. For all the theorising, however, one feels that what really aroused the instinctive painter in *The Dance* was the depiction of rapid movement and the two sources of contrasting light – the silvery moonlight in the great bay window and the illuminated chandelier, conveyed in a bravura passage that shows Hogarths brushwork at its most vigorous and assured.

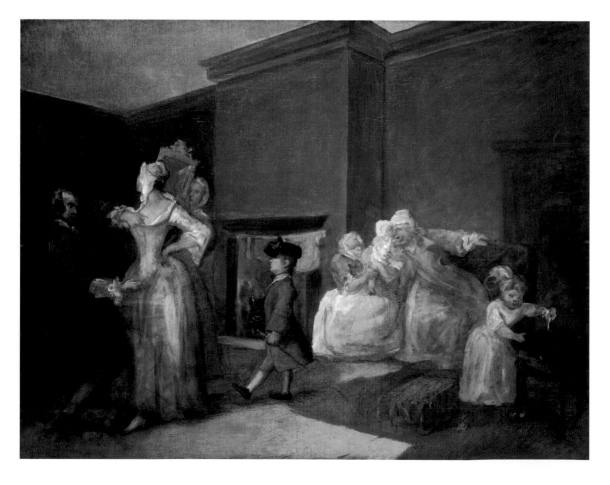

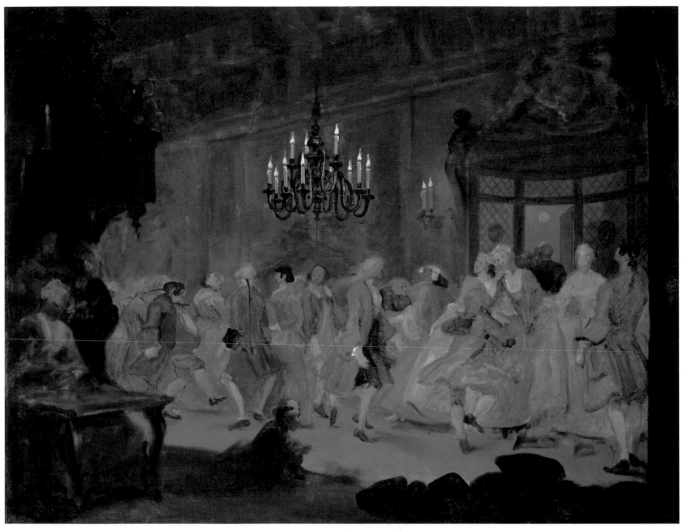

22

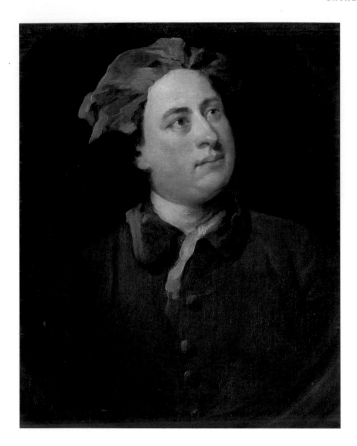

23 Man in a Green Velvet Cap c.1745

Oil on canvas 61 × 48 (24 × 18⅞)
Government Art Collection

This previously unrecorded portrait of an unknown man was probably painted in the 1740s, or even later, when Hogarth was the leading portrait painter of his day. The casual dress and inspirational upward gaze suggests that the sitter is someone belonging to Hogarth's circle of artistic or literary friends. The fact that the painting is executed on a much re-used and reduced piece of canvas which bears the traces of at least three previous portraits of different people, further suggests that this was not so much a formal commission as a fairly informal exercise. The handling of the paint is broad and assured, particularly in the rendering of the floppy velvet cap and matching collar. As usual, Hogarth homes in unerringly, indeed unflatteringly, on the sitter's physical presence, bringing out the watery blue of the eyes and the well-fed pinkness of the flesh.

24 The Mackinen Children 1747

Oil on canvas 180 × 143 (70⅞ × 56)
The National Gallery of Ireland

The picture shows Elizabeth and William, aged respectively seventeen and fourteen, the children of William Mackinen, a wealthy sugar plantation owner in Antigua. According to family tradition which there is no reason to doubt, this splendid picture was painted in 1747, presumably during a period when the children had been sent to England for their education. Elizabeth married and died in Antigua, but William returned to England in 1798 to live on his estate at Binfield, near Windsor, where he died in 1809. Through the Scottish origins of the family he succeeded in the last year of his life as the 32nd chief of the clan Mackinnon, which is how the name was spelt from then onwards. The family set great store by its illustrious highland descent (William's father had travelled to Edinburgh in 1726 to record his pedigree in the Office of the Lord Lyon King of Arms), and the prominent sunflower, a traditional symbol of loyalty, could be either a reference to this, or be emblematic of loyalty to the Hanoverian cause at a time when, in the wake of the Jacobite rebellion of 1745, Scottish connections could be a dubious asset.

The beautifully painted heads of the children sit slightly awkwardly on bodies which seem a trifle too small for them. This suggests that Hogarth had time only to take their likenesses, making the rest of the picture fit the heads in the absence of the sitters. The girl makes as if to rise from her chair, trying not to spill the sea-shells (perhaps a reference to their abode overseas) in her lap, while her brother reaches for a butterfly that has alighted on the sunflower. The open book in his other hand is a fitting prop for a youth at his studies. Numerous changes show that Hogarth did not find it easy to arrive at this unusual composition which was clearly meant to combine unconventional, spontaneous movement with a touch of grandeur, conveyed by the formal architectural setting and the large size of the painting itself.

Lit: R.L.S. Cowley, 'William Hogarth's "The Mackinnen Children"', unpublished article 1986; Mary Webster, catalogue of Hogarth exhibition, Fondazione Giorgio Cini, Venice 1989 (145); Mary Webster, 'From an Exotic Home', *Country Life*, 28 September 1989, p.151, repr.

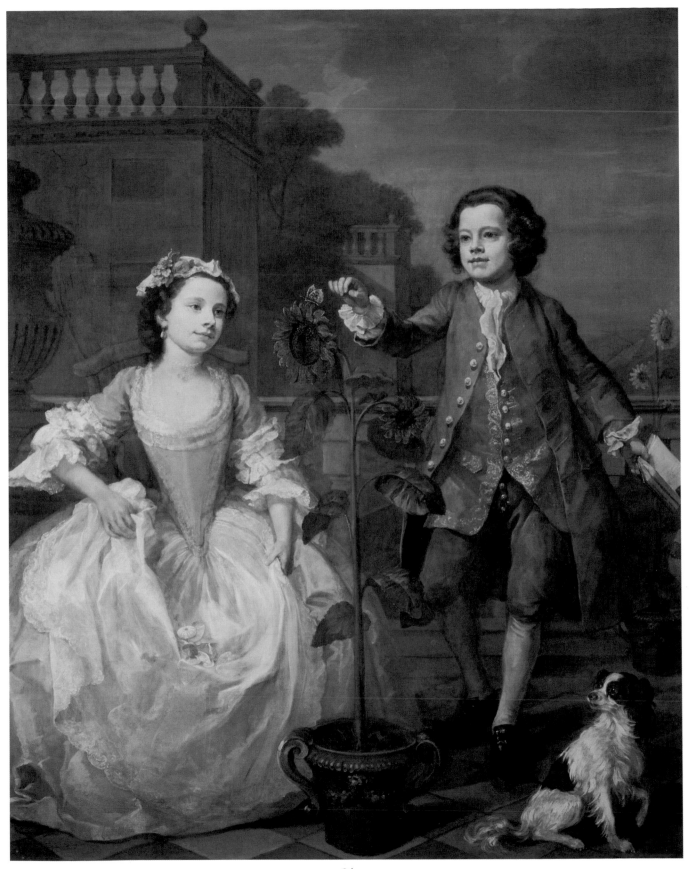

24

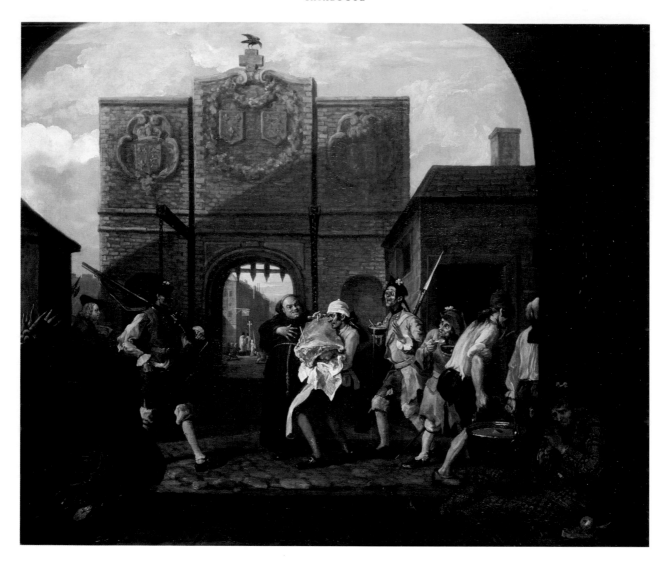

25 O the Roast Beef of Old England ('The Gate of Calais') 1748

Oil on canvas 78.8 × 94.5 (31 × 37¼)
Tate Gallery NO1464

On Hogarth's second visit to France in the summer of 1748 he ran into trouble when he was arrested at Calais as a spy. Delighted that the arms of England were still visible on the old city gate, he had settled down to sketch it, whereupon the French guards, jittery despite the newly concluded peace between the two countries, hauled him before the commandant for drawing the town's military fortifications. Hogarth soon established his artistic credentials, but was put back on the next boat to England with a caution. This farcical incident was meat and drink to Hogarth's satirical bent, and as soon as he returned home he dipped his brush in vitriol to wreak revenge. Piling every ounce of xenophobia into what is perhaps the largest and best-painted caricature in Western art, he creates an imaginary theatrical tragi-comic tableau of clever plots and subplots that is also a modern history painting, simply because

modern history (of a sort) is its subject. He also plugged astutely into a vein of popular sentiment by using the title of a catchy tune that had enjoyed top billing for more than a decade, which extolled roast beef as the symbol of British well-being and power. Predictably, the prints that he produced after the painting sold well, and both image and tune entered the canon of British nationalistic imagery. They remain there to this day, resurfacing lately with a horrible irony in the current European crisis regarding infected British beef.

The heroic centrepiece of the composition is a huge piece of British beef that has just landed for the English inn at Calais. In some prints it was the only touch of colour – bright red, of course – while in the painting it is lovingly cradled in the only touches of pure white paint. It is being prodded enviously by the only fat Frenchman in sight, a Franciscan friar, modelled with even-handed jokiness on Hogarth's friend the engraver John Pine. Visually, it is placed against one of the chains of the drawbridge so that it appears to outweigh the scrawny 'puppet' soldier on the other side. A group of coarse French fishwives and a starving Scotsman, a Jacobite refugee after the Scottish

rebellion of 1745, flank the off-centre proscenium arch where representations of the Muses were usually found in the theatre. On the left, enclosed in a spiky triangle of weapons and the vegetables so despised by the British, sits Hogarth, with the guard's heavy hand already upon his shoulder. Beyond the group of starveling mercenaries, the view though the gate reveals the true 'spirit' of the enemy Catholic nation through a series of visual and verbal puns that can still draw blood: glimpsed as if through the gates of a prison, an ignorant and abject populace adores its cross, while the Holy Spirit is present only as an inn-sign. This parody is carried further by the sinister carrion-crow perched atop the stone cross of the gate, bending its beak greedily towards the British beef. The crow also symbolises, as the Black Bird badge of the kings of Scotland, the Jacobite threat.

26 Hannah, Daughter of John Ranby *c.*1748–50

Oil on canvas 63.5 × 55.9 (25 × 22)
Tate Gallery T07122

27 George Osborne, later John Ranby *c.*1748–50

Oil on canvas 64 × 57.8 (25⅛ × 22¾)
Tate Gallery T07121

Hannah (1740–1781) and George Osborne (1743–1820) were the natural children of Dr John Ranby, physician to the royal household and a friend and neighbour of the Hogarths at Chiswick. Although their unknown mother died in 1746, both children were evidently well cared for and did well in later life. Hannah married Walter Waring, a wealthy Member of Parliament; George, who was brought up as Ranby's heir and changed his name to John Ranby by royal licence in 1756, went to Eton and Cambridge, and prospered as a lawyer and a landowner.

Most eighteenth-century portraits of children present them as dignified little adults. Hogarth, too, upholds their dignity as if to negate their illegitimate status, but lets a sense of barely contained childish mischief surface in the case of George, and delights in the girlish freshness of his older sister. It is also typical of Hogarth to bring out the strength of individual character even in sitters as young as this. His assured modelling of the strong contrasts of light and shade represents his mature portrait style at its best, revelling in the animated flutter of ribbon and neck-tie, and in details like the nervy highlight that traces the edge of Hannah's starched cap.

The garlanded sculptured stone surrounds are an unusual elaboration of the plain stone false oval in which bust portraits of this period are often set, and may reflect a particular request of Ranby's. The portrait of the boy was clearly painted in one piece, while that of Hannah was later adapted to match it, its original plain oval still clearly visible underneath the Rococo scrollwork. One can speculate that this monumental format might have been an attempt to present the children as a memorial to their deceased mother, or to acknowledge their dynastic position – especially in the case of George – as Ranby's heirs.

26

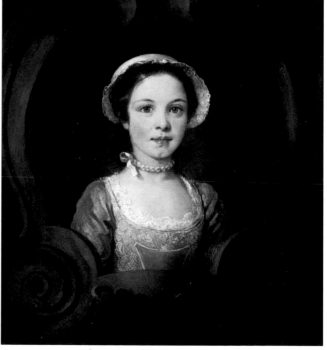

27

28 Heads of Six of Hogarth's Servants *c.*1750–5

Oil on canvas 63 × 75.5 (24¾ × 29¾)
Tate Gallery NO1364

This study of six servants of Hogarth's household is one of the most unexpectedly spontaneous works in British portraiture. Their names are unknown, with the exception of an old servant called Ben Ives, who could be the old man in the top right-hand corner. Although all the heads have been brought to a high degree of finish, their placing on the typical buff ground shows that the picture was never intended to be a finished composition. While it seems to have been created for the sheer love of painting, or out of affection for the people represented, it may have also hung in Hogarth's studio – where it

remained for his lifetime – to demonstrate his ability to paint the flesh tones of sitters of all ages. Indeed the picture echoes the kind of categorising accumulations of heads and objects, met with frequently in Hogarth's graphic work, that illustrate the full range of some given concept, in this case all the facial characteristics from youth to old age.

What is surprising in a work that appears to have been put together in such a random fashion is its dignified monumentality. This is due not only to its scale, but also to the completely uncondescending and serious manner in which each sitter is represented. Unity is achieved through all the heads being lit from the same side, and by the fact that each sitter looks out at his or her own separate focal point, without any of their lines of vision being allowed to intersect.

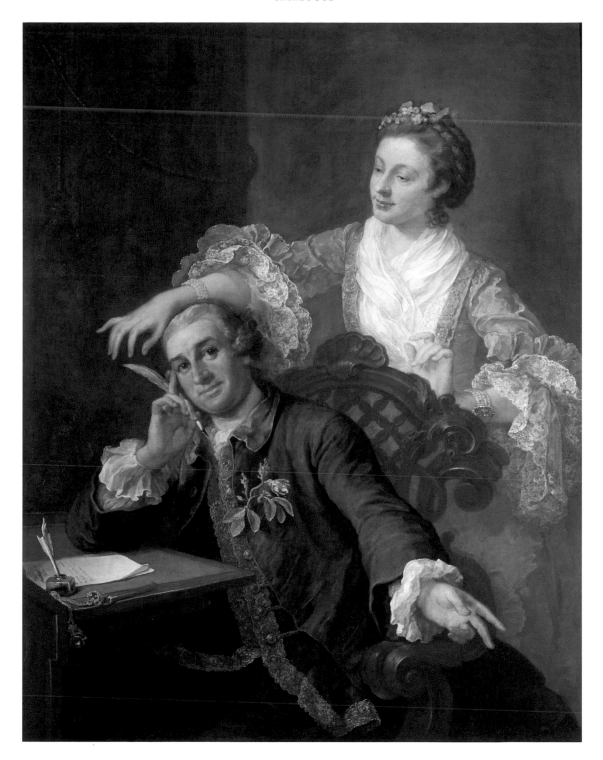

29 Mr and Mrs Garrick 1757

Oil on canvas 132.6 × 104.2 (52¼ × 41)
Signed '… Hogarth' bottom left
Her Majesty The Queen

This picture shows David Garrick (1717–1779), the greatest actor of his age and Hogarth's lifelong friend, composing his prologue to Samuel Foote's *Taste*, a comedy that pilloried the ignorant pretensions of would-be art connoisseurs, a subject dear to Hogarth's heart. Garrick's declamatory concentration is about to be teasingly interrupted by his wife, the beautiful and accomplished Viennese dancer Eva-Maria Veigel, whom he had married in 1749. The nature of their long and extremely happy marriage is felicitously expressed in this grand and elegant double portrait, which also acknowledges that Mrs Garrick was in many ways her husband's controlling muse. The Revd John

Hoadly, a warm friend of both Garrick and Hogarth, saw this picture almost finished in April 1757 and recognised its outstanding qualities. He described the portrait to a friend as 'a most noble one of our sprightly friend' and thought its playful action in no way excessive, but just 'enough to raise it from the formal inanity of a mere Portrait'.

As usual, Hogarth agonised over the composition and made many adjustments. Originally the background was to have been a busy assemblage of shelves, books, prints and various domestic objects, but this was painted out at an early stage, possibly, it has been suggested, because these details looked too unfinished (the picture was still in Hogarth's studio at his death). However, the background could have equally well been painted out by the artist himself as he considered it sufficiently completed to add his signature. There are also precedents (see no.19) that show that in his grander portraits Hogarth sometimes made a deliberate effort to suppress his natural urge to fill every available space with telling detail in order to achieve a stronger, simpler composition.

Lit: O.Millar, *The Royal Collection: Tudor, Stuart and Early Georgian Paintings*, 1963, p.185, no.650.

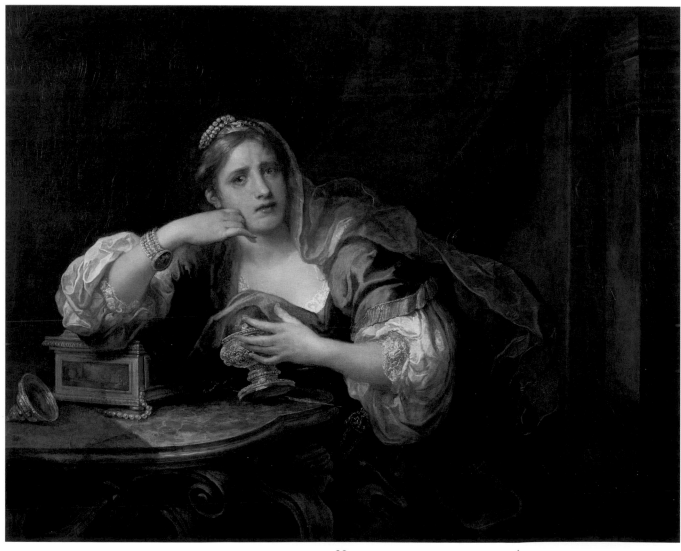

30

30 Sigismunda Mourning over the Heart of Guiscardo 1759

Oil on canvas 100.4 × 126.5 (39½ × 49⅞)
Signed 'W.Hogarth pinx!/1759' bottom right
Tate Gallery N01046

The subject is taken from Boccaccio's *Decameron*, as retold in Dryden's *Fables* published in 1699. It is the tale of the Princess Sigismunda, who falls in love with and secretly marries one of her father's attendants. Enraged by the unequal match, the king has Guiscardo killed, and sends his heart to Sigismunda in a golden goblet. Overcome with grief, Sigismunda takes poison and dies in front of her remorse-racked father.

The picture began as a *carte blanche* commission in 1758 from the immensely wealthy young collector Sir Richard Grosvenor, who asked Hogarth to choose his subject and to name his price. Unfortunately for him, instead of producing a delicious Rococo genre piece in the £100 range, which was what Grosvenor probably expected, Hogarth decided to make his picture a vehicle for an attempt to outrank an Old Master, in this case an undistinguished picture of the same subject, wrongly attributed to Correggio, that had just fetched the unprecedented sum of more than £400 at auction. When Hogarth asked the same price for his modern masterpiece, Grosvenor's cool response made it plain that he found the painting distasteful. Deeply wounded, Hogarth released him from the agreement; his self-esteem never recovered from the blow. The painting remained in his studio, and he instructed his wife not to sell it for less than £500 in her lifetime (it fetched just over £58 after her death).

Traces of innumerable repaintings and corrections to the composition attest to the immense effort that Hogarth put into this picture. The fact that Sigismunda seems to have been modelled on his wife Jane, as she appeared when she was mourning over the death of her mother Lady Thornhill in 1757, added to the emotional involvement. This is corroborated by the presence of the artist's self-portrait as a carving on the table-leg facing his wife, perhaps as a reminder that they too began their married life in the face of Sir James Thornhill's paternal disapproval.

In the context of its time, the picture is, in fact, a serious and dignified exercise in the epic style, able to stand comparison with similar but much more favourably received works by, for instance, Sir Joshua Reynolds. Today its weaknesses seem to stem largely from Hogarth's anxiety to succeed and in the consequent loss of spontaneity. But at the time at least some of the criticism it attracted must be attributed to the mental compartmentalisation of the day: pundits did not like artists who were insufficiently 'fixed to any one point in art' (the reason still given, for instance, for denying Philip Reinagle membership of the Royal Academy half a century later). A painter who succeeded in small scale comic histories had no business grappling with heroic subjects. As a young man Reynolds painted some brilliant caricatures, but quickly abandoned the genre so as not to spoil his image as a painter of the Grand Style. Hogarth's instinct was to break down such artificial barriers, and he was probably right to think that, covered with dark varnish and with a false Italian signature attached, his *Sigismunda* might have been hailed as a masterpiece by quite a few of her detractors.

31 Inigo Jones 1757

Oil on canvas 91.5 × 71 (36 × 28)
National Maritime Museum, Greenwich

This portrait of Inigo Jones (1573–1652), Britain's most famous classical architect, was commissioned from Hogarth by Sir Edward Littleton, MP, (c.1725–1812) of Teddesley Hall, Staffordshire, who was refurbishing his mansion in the neoclassical style in the 1750s. We are not sure how this unusual commission came about, but Sir Edward was a studious connoisseur interested in the arts who at about the same time bought Rysbrack's terracotta model, now in the Victoria and Albert Museum, for the chimney piece of the Foundling Hospital, to be installed in his own house.

Hogarth maintained that the accepted practice in a young painter's training of copying Old Masters dulled the artistic imagination, although he admitted having learnt to do so himself 'with tolerable exactness' when he was studying to be a painter. At the same time he passionately admired the Rubens-Van Dyck-Lely-Kneller tradition of portraiture in Britain and wanted to be seen as part of it. He considered 'Vandyke one of the best portrait painters in most respects ever known', and placed a gilt cork bust of him (*The Golden Head*) as his trade sign over the door of his house in Leicester Square. When a friend ventured to say that he was as good a portrait painter as Van Dyck, Hogarth is said to have replied 'and so by G – I am, give me my time, and let me choose my subject.'

Here Hogarth was given the chance to prove his mettle, and he rose to the occasion brilliantly. This was not a case of copying an Old Master, but of reconstructing an image in the spirit of his great predecessor. Hogarth's two letters to Sir Edward Littleton, preserved with the portrait at the National Maritime Museum, state that the picture was finished by May 1757 and that it was 'painted after the print of Inigo Jones'. This refers to the engraving made in the 1630s by Robert van der Voerst for *The Iconography*, a collection of portrait prints after drawings and paintings by Van Dyck published in Antwerp after his death. The engraved image, which Hogarth follows closely, is in reverse to Van Dyck's red chalk drawing in the Devonshire Collection, Chatsworth, which in turn is an elaboration of a much-copied bust portrait in oils, showing the architect dressed in sober black and white, now in the Hermitage, St Petersburg. Hogarth translated the print into a vibrant, digni-

fied portrait, using subtle, muted colours that show that he had looked at Van Dyck's technique very closely. The dark blue sky and red curtain in the background, for instance, occur in a number of Van Dyck paintings Hogarth could have seen, including those in the Royal Collection. With the composition of a great master to guide him, the picture is free from the hesitancies and second thoughts that usually attended Hogarth's creative process, leaving him free to concentrate on the rich, fluent brushwork, handled with an evident delight in the process of making paint evoke a real presence.

31

SELECT BIBLIOGRAPHY

Antal, Frederick, *Hogarth and his Place in European Art*, 1962

Beckett, R.B., *Hogarth*, 1949

Bindman, David, *Hogarth*, 1981

Burke, Joseph (ed.), *William Hogarth: The Analysis of Beauty with Rejected Passages from the Manuscript Drafts and Autobiographical Notes*, 1955

Cowley, Robert, *Marriage A-la-Mode: A Re-view of Hogarth's Narrative Art*, 1983

Dabydeen, David, *Hogarth, Walpole and Commercial Britain*, 1987

Einberg, E. and Egerton, J., *The Age of Hogarth: British Painters Born 1675–1709*, 1988

Jarrett, Derek, *The Ingenious Mr Hogarth*, 1976

Kitson, Michael (ed.), 'Hogarth's "Apology for Painters"', *Walpole Society*, vol.41, 1966–8

Lindsay, Jack, *Hogarth: His Art and His World*, 1977

Nichols, John, *Anecdotes of William Hogarth, written by Himself: with Essays on his Life and Genius, and Criticisms of his Works*, 1833; reprinted Cornmarket Press 1970

Paulson, Ronald, *Hogarth's Graphic Works*, 2 vols., 1965; revised edition 1989

Paulson, Ronald, *Hogarth: His Life, Times, and Art*, 2 vols., 1971; abridged edition, 1974; revised edition, 3 vols., 1991

Paulson, Ronald, *The Art of Hogarth*, 1975

Paulson, Ronald, *Popular and Polite Art in the Age of Hogarth and Fielding*, 1979

Shesgren, Sean, *Hogarth and the Times-of-the-Day Tradition*, 1983

Webster, Mary, *Hogarth*, 1978

LENDERS

Her Majesty The Queen 29
Thomas Coram Foundation for Children, London 11
Government Art Collection 23
National Gallery of Ireland, Dublin 24
National Gallery, London 8, 18

National Maritime Museum, Greenwich 31
National Portrait Gallery, London 13
The Earl of Macclesfield 12
Private Collections 17, 20
Tate Gallery, London 1, 2, 3, 4, 5, 6, 7, 9, 10, 14, 15, 16, 19, 21, 22, 25, 26, 27, 28, 30

PHOTOGRAPHIC CREDITS

Bristol Museums and Art Gallery
Crown Copyright: UK Government Art Collection
Marcella Leith
Marcus Leith
The Paul Mellon Centre for Studies in British Art, London

National Gallery of Ireland, Dublin
National Gallery, London
National Museums and Galleries on Merseyside
National Portrait Gallery, London
The Royal Collection
St Bartholomew's Hospital, London
Tate Gallery Photographic Department

LIST OF EXHIBITED WORKS

Numbers refer to catalogue entries

A Scene from *The Beggar's Opera* **VI**
Tate Gallery. Purchased 1909
no.2

Captain Thomas Coram
Thomas Coram Foundation for Children
no.11

Ashley Cowper with his Wife and Daughter
Tate Gallery. Purchased with assistance from the Friends of the Tate Gallery 1966
no.3

The Dance (The Happy Marriage VI: The Country Dance)
Tate Gallery. Purchased with assistance from the National Heritage Memorial Fund 1983
no.22

Mrs Desaguliers
Private Collection
no.20

Lavinia Fenton, Duchess of Bolton
Tate Gallery. Purchased 1884
no.16

Mr and Mrs Garrick
Her Majesty The Queen
no.29

The Graham Children
Trustees of the National Gallery, London
no.18

Head of a Lady, called Lady Pembroke
Tate Gallery. Purchased 1994
no.7

Heads of Six of Hogarth's Servants
Tate Gallery. Purchased 1892
no.28

Thomas Herring, Archbishop of Canterbury
Tate Gallery. Purchased 1975
no.19

Benjamin Hoadly, Bishop of Winchester
Tate Gallery. Purchased 1910
no.14

A Performance of *The Indian Emperor or The Conquest of Mexico*
Private Collection
no.4

Inigo Jones
National Maritime Museum, Greenwich
no.31

William Jones
National Portrait Gallery, London
no.13

The Mackinen Children
The National Gallery of Ireland
no.24

Man in a Green Velvet Cap
Government Art Collection
no.23

O the Roast Beef of Old England ('The Gate of Calais')
Tate Gallery. Presented by the Duke of Westminster 1895
no.25

The Painter and his Pug
Tate Gallery. Purchased 1824
no.1

George Parker, 2nd Earl of Macclesfield
The Earl of Macclesfield
no.12

Thomas Pellett MD
Tate Gallery. Bequeathed by Miss Rachel and Miss Jean Alexander 1972
no.9

James Quin, Actor
Tate Gallery. Purchased 1904
no.10

George Osborne, later John Ranby
Tate Gallery. Presented by Mrs Gilbert Cousland 1996 to celebrate the Tate Gallery Centenary and the Hogarth Tercentenary 1997
no.27

Hannah, Daughter of John Ranby
Tate Gallery. Presented by Mrs Gilbert Cousland 1996 to celebrate the Tate Gallery Centenary and the Hogarth Tercentenary 1997
no.26

Mrs Salter
Tate Gallery. Purchased 1898
no.15

Satan, Sin and Death (A Scene from Milton's *Paradise Lost*)
Tate Gallery. Purchased 1966
no.5

The Shrimp Girl
Trustees of the National Gallery, London
no.8

Sigismunda Mourning over the Heart of Guiscardo
Tate Gallery. Bequeathed by J.H. Anderdon 1879
no.30

The Staymaker (The Happy Marriage V: The Fitting of the Ball Gown)
Tate Gallery. Purchased with assistance from the National Art Collections Fund 1942
no.21

The Strode Family
Tate Gallery. Bequeathed by Revd William Finch 1880
no.6

Unknown Gentleman in Grey, Holding Gloves
Private Collection
no.17

AFGHANISTAN:
A TOUR OF DUTY

Photographs by **Captain Alexander Allan**

AFGHANISTAN: A TOUR OF DUTY

Photographs by Captain Alexander Allan

THIRD MILLENNIUM
PUBLISHING, LONDON III

Text and Photographs © 2009 Alexander Allan
Design © 2009 Third Millennium Publishing Limited

First published in 2009 by Third Millennium Publishing Limited,
a subsidiary of Third Millennium Information Limited.

2–5 Benjamin Street
London
United Kingdom
EC1M 5QL
www.tmiltd.com

ISBN 978 1 906507 39 8

British Library Cataloguing in Publication Data:
A CIP catalogue record for this book is available from the British Library.

Edited and photographed by Alexander Allan
Designed by Matthew Wilson
Production by Bonnie Murray
Reprographics by AGP Graphics
Printed by Gorenjski Tisk, Slovenia whom the publishers wish to thank for their
generous support in making this charity edition possible.

CONTENTS

FOREWORD

General Sir Richard Dannatt GCB CBE MC

The British Army has been tested time after time over the centuries, and three times previously in Afghanistan. But we do what we do only at the behest of our Government, in the name of our Nation and in the service of our Sovereign. That is the job of the British soldier. We know that, and we get on with it. After all, these days we are all volunteers. But when the great British public says thank you when we come home, we march ten feet tall and enjoy the moment. Frankly, after forty years in the business, I am firmly of the view that it is a fine and honourable thing to be a British soldier, but it is an equally fine and honourable thing to support the British soldier. So thank you, for buying and reading this book.

For me, this wonderful book is a graphic record of British soldiers' day-to-day experiences serving in Afghanistan. They happen to be Grenadiers, who by tradition and reputation are very special, but in Afghanistan they could be any other British infantry regiment devoted to the task of supporting the democratic process, increasing security and training Afghan troops so that in the long-term they can take over the responsibility for a free Afghanistan themselves. But along with service, sadly, comes sacrifice, and this photographic record does not flinch from the issue. Readers will get an authentic insight into the realities of life for the British soldier on Afghanistan's front line. However, they should also be reassured to know that all profits from the sale of this book will, at the wounded soldiers' own request, go direct to the charity which supports and cares for those who have lost limbs in service. Such motivation and service is truly humbling.

© Sergeant Will Craig

INTRODUCTION

Captain (Rtd) Alexander Allan

In Afghanistan the majority of my Regiment were deployed as Observation Mentoring and Liaison Teams (OMLT or ' 'omelette' in military parlance), we were there to:

Train, mentor and strike in support of the Afghan National Army (ANA) 3/205 Brigade in order to enable the continued progress toward 3/205 Brigade becoming a self-sufficient, sustainable, proven all-arms Brigade.

Each UK Officer or Non-Commissioned Officer would mentor a more senior ANA commanding counterpart. The idea was that a full Corporal or Lance Sergeant would mentor an ANA Platoon Sergeant and our Commanding Officer; the Battalion Commander would mentor an ANA Brigade Commander. The reality was that the mentor relationship was often less structured and that there was a lot more striking than mentoring, and almost no training done due to the fast operational tempo that was demanded of the ANA.

Although living and working with nationals of such an exotic country enriched our experience, working with the ANA had its challenges. In battle, command and control of your sub-units is most often the deciding factor between success and failure. If fighting was not unpredictable enough, the added complication of a language and cultural barrier to impede communication added to the complex situation. From the Commanding Officer (pictured with General Dannatt) down to the youngest Guardsman, it was a tiring job of empathy, diplomacy and leadership.

These images differ from most media that returns to the networks in the West, because one of the participants has taken the pictures. I believe my relationship as an equal rather than an outsider allows for a refreshingly honest and candid perspective from the inside.

Afghanistan is a country with incredibly warm light; its people are both striking and charismatic and, although in a desperate situation, they retain the ability to enjoy family and laughter. Add to this the tentative exploration by alien people of this new land and culture and you can begin to understand the richness of the subject matter. We, too, suffered a discomfort with the situation but we did everything possible to make good of the bad and to ensure that we did a job to the best of our capabilities. Some write prose, some poems, others are raconteurs telling their stories as best they can to an eager audience. These pictures are my diary; take from them what you wish.

'The night I arrived in Helmand I read a letter given to me by a close friend prior to leaving London. In it she urged me to do my duty, but also to make sure that I came home alive. Her entreaty was particularly poignant because the previous year her boyfriend and I had served together in Iraq. He had been killed by a roadside bomb in Basrah.

Sitting alone, reading her letter, it was hard not to be daunted by the enormity of the challenges that lay ahead.'

– Captain Charles Leigh Pemberton (aged 27)

No matter how comprehensive the training or extensive past personal experiences, you could not be anything but bowled over by the richness of this country. Ethnically diverse people with striking looks living in close fertile settlements constructed along the river Helmand amidst magnificent expansive deserts. The experience was punctuated by a concoction of smells, coming from this world 300 years less developed than our own, and by the sounds of conflict.

An ANA OMLT section – two UK mentors

Two worlds: the desert and a settlement on the edge of the green zone.

*The desert is the safest
transit route for tactical
and logistic moves.* ▼

▲ *Irrigation ditches visible from the air but not the
ground, excellent defensive positions and egress
routes. The Soviets destroyed hundreds of kilometres
of them due to the threat to occupying troops.*

The Afghan National Police (ANP) surveying their own crop of opium poppies – poppy eradication will set the Coalition's hearts-and-minds campaign back. You can quantify it in time, money, Afghan and Coalition lives lost. Policy must be ironed out to accommodate poppy cultivation.

ANA comrades. Very seldom did we see any women, and it would never have been appropriate to take photographs of them.

This family had recently moved back to
their family home, having lived in the desert
for several years. Their return was a result
of the stability brought by UK forces. Despite
this, feelings toward us were mixed. ▲

▲ A proud, suspicious and temporarily
accommodating look was the norm.

*According to UN statistics, Afghanistan is the
fifth least developed country in the world.*

*A young boy returns home after a
day's work collecting animal feed.*

*Waiting for Hamid Karzai to arrive by air to inspect
the troops. In the event, the visit was a no-show.*

The Regimental Sergeant Major, James Keeley, and his Afghan counterpart.

We fought and trained side by side with the Afghan National Army, whose
men are keen to learn and brave in battle, their only weaknesses being
discipline and logistics. In a way, our going home feels almost like a betrayal
of these trusted, generous men whom we have left to carry on the fight.

The ANA's understanding of the local environment and people was invaluable.

Guardsman Z, right, a British Muslim, is primarily
an infantry soldier but also an interpreter for his
company commander, Major Elliot-Square. His
relationship with the Afghans is typical of those of
the young soldiers, who can bond across cultural,
religious and language barriers.

*ANA soldiers represented the ethnic diversity of Afghanistan:
Uzbeks, Tajik, Hazaras and the dominant Pashtun.*

The job of the ANA (with our assistance) was to dominate their area of operations by showing a constant presence on the ground. The intent was and is to restrict the freedom of movement of the enemy. Often carried out in vehicles, the majority of the time this was done by patrolling on foot, in 50°C (122°F) heat and over difficult terrain. Whilst on patrol it was essential to converse with the locals in order to gain their confidence and subsequently inform us of Taliban movements in the communities. Weeks would be punctuated by specific intelligence-led targets or incidents involving friendly forces needing assistance in the area. The physical drain on all of us was apparent, and the constant fear of losing someone was a burden on all, but especially on the commanders.

Major Marcus Elliot-Square. Whilst on leave meeting ▲
his first and newly born daughter Charlotte, he was informed
that his company had lost Gdsm Tony Downes to an
Improvised Explosive Device (IED) the same day.

▲　Lt Florien Kuku suffered severe shrapnel wounds to his leg and shoulder in an IED explosion. Now a Captain, he is back in Afghanistan two years later.

Talib!

A close encounter, having had our lead section ambushed. This sequence shows the fire support that facilitated our withdrawal from the open ground.

Two junior ANA soldiers who were sent ahead to clear the wadi with nothing but their boots survived the IED. The two ANA sergeants who remained in the vehicle to cross were killed instantly. The bond between the ANA and us grew after we helped them extract their dead and tend to the wounded.

The ANA casualty rate was far higher than that of Coalition forces, owing to relatively little protective equipment and perhaps a slightly different attitude to risk and death.

▶ An Afghan soldier gets his breath back after nearly being hit by Taliban fire.

◀ The air is filled with dust as mortars punish the enemy position.

In these conditions the physical and psychological pressures on soldiers are extreme. Briefings, their training and their equipment help them to deal with combat stress, but it cannot be relieved totally. Besides carrying more than a third of his bodyweight, a soldier must learn to cope with the continual threat of violence and death, and the loss of comrades.

Back on patrol at dawn. The cool of the night quickly disappears in the sweltering sun.

Gdsm Bangham and Gdsm Harrison,
attached to the Royal Anglian
Regiment, with an assault ladder.

Later that month, Guardsman Harrison was
shot in the head and subsequently lost
the sight from his right eye. The following
is taken from his citation for his MID
(Mention In Despatches):

*'Guardsman Alexander Harrison –
Harrison remained alert and calm at all times
despite sustaining a gunshot to the head at
close quarters. The bullet entered behind his
right ear and exited through his right eye.
Before collapsing he drew a model of the
enemy locations so as to aid their defeat.'*

*LSgt 'Goolie' Ball, at 21 the youngest
NCO of his rank in the Regiment.*

Gdsm Highton, age 19.

Young soldiers have a lot in common, despite having to deal with divisions of culture, religion and language.

Zorbet (Sergeant) Sultan, the finest Afghan soldier I came across, dressed in LSgt Housby's equipment. Lost both legs in an explosion a week later. A comrade suggested that he would have been better to die than lose both his legs: 10 months later he died of his injuries. ▼

▲ *This ANA slodier, captured by the Taliban, was only released once they had clipped his ear. The Guardsmen named him 'Papa Smurf'.*

Waiting in reserve with the battle raging 50m away; the compound walls were as good as any bunker.

▲ *On patrol in a village.* | ▶

We had very little time to train the teams, so on an extended patrol we set up ranges in the safety of the desert to work on the ANA weapon skills. The silver lining of their varying accuracy was the hope that the Taliban with the same weapons had the same attitude to the science of marksmanship.

*LCpl Macfarlane, with interpreter, demonstrating
the correct firing position to an ANA soldier.*

The Taliban ambush an ANA vehicle. The ANA had been stealing from the locals, and the Taliban exacted revenge. The rule of law is fragile, and actions by the security forces such as this play directly into the hands of the enemy, setting back our work, perhaps irreparably.

Each patrol base was more than a fighting and logistic hub, it was our home. In it we removed ourselves from the rigours of the days before and those to come, with little other than each other's company and treats sent from home to pass the time. In our final patrol base we were spoiled with a farmer's water tank in which we relaxed and washed with the ANA.

LSgt Housby tries to catch
some sleep in the midday heat.

Sgt Duvall sits with Gdsm Bance, a battlefield casualty replacement just out of training, who two weeks earlier was on the forecourt of Buckingham Palace wearing a bearskin. ▼

▲ *The water tank – an unimaginable luxury.* I
▶

Sgt Duvall sits fatigued, in his personal space. The shoe box under his bed was addressed 'to a Soldier'. It was from 'the Red Lion Pub' – very touching and great morale for us all.

Self-portrait.

LSgt Ball smokes a cigarette inside his mosquito net. Soon to lose his leg when pushing forward to give covering fire for his section after another device had killed our interpreter and taken both legs of an Afghan sergeant.

Food made a huge contribution to morale. |

Afghan soldiers sit on the helicopter pad as the evening dust storm approaches. With unsettling fascination, they would watch the British soldiers playing touch rugby.

*Completely unfazed by the earsplitting explosion
500m away, one ANA prays and another smokes
a joint as the remainder investigate.*

Passing time in the evening, LSgt Ball considers his final move against LSgt Housby (who was on radio duty).

A time for normality: weekly dinner prepared in turns by each team in a competition to provide the best spread possible with what was available. The weekly dinner was especially important in helping to integrate the newer soldiers – battle casualty replacements (BCRs) – into such a tight team.

For the sake of hygiene, waste (personal or otherwise) was burned. I'll never forget the acrid stench.

*Pizza delivered from Camp Bastion
thanks to the generosity of the Royal
Engineer Explosives Ordnance Disposal
Team who were stuck in our tiny base
for 24hrs – ordered by SAT phone,
delivered by Chinook.*

*Southern-style chicken: 2Lt Tom Hamilton decided Osama and Saddam (our chickens)
were to be one week's dinner. Both were Halal butchered by the ANA chef.*

Monday, September 7

'The bright flash and the bang, it was pretty loud … I was on top of it, I was thrown up in the air and hit the ground hard, my helmet rolled off. I scrabbled around for my secondary weapon system as the GPMG had gone, I could find nothing. The pain suddenly hit me hard, it was not a slow increase. I felt where the pain was coming from, I moved my hand down my left leg, the bottom half from the kneecap downwards was missing. I knew that the other UK soldiers were tending to the other two casualties who had been hit by the first IED, because I had assigned them that task, so I didn't call out, I set about applying my own tourniquet and field dressings.'

— LSgt 'Goolie' Ball

A routine patrol, to set up an over-watch position 800m from my base. A young commander, given his first command, briefed his men fully.

Incident, reaction, emotion, adrenaline, total reliance on training. Dark, confusion, three casualties – one half-dead with head wounds, one with both legs blown off – Goolie one leg gone, five Brits, twenty Afghans, the interpreter is the half dead casualty. Imminent follow-up from Taliban…

I never know how to relate this incident, especially to a civilian. For me it has played on repeat in military language so often that it is ingrained in that format. Pre-tour training warned us that regrets, decisions made and the burden of command could have wrecking consequences after any traumatic incident.

The burden of command.

LCpl Jones, a close friend of Goolie, had held him in the back of the Snatch Land Rover for the 20-min drive to the medical team in Sangin. His clothes and boots needed to be burned.

36 hours after the incident we found Goolie's foot and boot respectfully wrapped in cotton sheets by the side of the road. After checking that it was not booby trapped we took it back to base at the end of the patrol. This put our minds to rest that it was in our hands. We all stood around the rubbish fire during the cremation, my hope being that however perverse or shocking this may be we would do it together. It was our farewell. Later we took it in turns to individually stand guard over the fire. It was a refreshing reflective solitude which helped us all.

With 10 days to go till we reached home we were reluctant to do any more than the most immediate and necessary tasks. Although 5 miles away, Major Martin David, my Company Commander, sensed this and sent us a message which was the most tangible embodiment of leadership I have experienced. He paternally expressed his admiration and thanks for how we had dealt with the incident and communicated his empathy for our loss as it was a shared one – we knew he had experienced this situation too often throughout the tour. He then swiftly switched to the tone of a commander, reminding us that the situation had not changed, and gave us our patrol orders for the following day. We deployed on patrol, understanding that the situation was indeed unchanged, on a tactical level at least; emotionally, we suppressed our loss – there was no place for anything other than focus on the job in hand.

As Goolie flies off for medical care, we feel the crushing questions of self-doubt, decisions made and how the incident played out, all within the hollow emptiness of an adrenaline low.

Only 65p

Rea people

100% REAL LIFE

DEADLY LOVER

hired a hitman

A free pull out from a UK tabloid still interested in the obese woman that had had her life ruined by salt and vinegar crisps evoked uncertainty in my mind as to what I was returning to. For me returning home was about seeing my family and girlfriend, drinking in a pub garden and being able to walk down the street without subconsciously scrutinising every movement and feature of my surroundings. The growing doubt stemmed from a revulsion of the UK's petty attitudes, especially those depicted by the media.

This uncertainty tarnished the anticipation of my homecoming, which I had once held on an untouchable pedestal.

We had fought for the safety and security of the Afghan people and witnessed, albeit only in tiny pockets, an increase in the standard of living of some of the world's poorest people. I felt I had a better understanding of what truly mattered to a society surrounded by incessant intimidation and conflict – family, honour, respect and generosity.

Perhaps this is the prerogative of a wealthy and content nation to which I should be happy to return.

LSgt Baylis and Sgt Gillies express their relief to be lifting off from Sangin homeward bound. In 72 hours LSgt Bayliss would be home with his heavily pregnant wife Dawn and 17-month-old daughter Katie. There should have been another ten members of the company on that flight. ▼ ▶

▶ On the same helicopter, LSgt Housby is on his way to a further five-week attachment in southern Helmand.

Terrifying that my tour was quiet. Eleswhere, British officers and soldiers suffered immeasurably more than I did … Others are doing so today in all the same places, and other far corners of British civilian consciousness, but at the forefront of our democratically elected foreign policy.

They will be there today, as they will be tomorrow.

Yours, ever.

A very average Officer

RECOVERY AND DETERMINATION

Lance Sergeant Adam 'Goolie' Ball

As I drifted in and out of consciousness before being airlifted to Camp Bastion, my last memories in Helmand are primarily of excruciating pain. I saw Maj David and the CSM looking down, drips going into me and talk of IRT helicopter on its way. The next and last recollection was looking up at the RAF Chinook loadmaster, his helmet and visor covering his face, saying 'We're off to Bastion, you are safe now…'

I woke up still in a haze, shouting for Captain Allan at the top of my voice. My mind and body were numbed by drugs and I remember being terrified to see my mother and brother in the room. I angrily instructed them to return immediately to England and to make sure they had adequate support on their way. It took a couple of days, drifting in and out of horrendous nightmares and hallucinations, to finally accept that I was in intensive care in Selly Oak Hospital in Birmingham.

My life since returning to the UK has seemingly been an endurance test of two steps forward and one step back. Small steps, such as being in a wheelchair for the first time, allowing me freedom to transport myself, and the day the specialist told me that, despite the shortness of my stump, he could measure me up for a prosthetic, are some of my strongest and happiest memories. The highs are related to events which have allowed me to regain my independence in day to day activities.

With the positives came the negatives: expectations of treatment or recovery times were often over-optimistic, which would crush my morale. Due to an administrative mistake on my transfer from Selly Oak to the Forces Rehabilitation Centre at Headley Court, the removal of my colostomy bag was delayed by over seven months. I am a twenty-two year old leader of men, a soldier, shitting through a hole in my gut into a plastic bag for nearly two thirds of a year when I did not need to. This crushed me.

My life has been permanently changed, but I am still the same person I always was. I can still make the girls laugh and have been in relationships since. The loss of my leg is the visible side of my injury but not the one that restricts my return to a more 'normal' life. The pain resulting from the trauma suffered by my nervous system is my ultimate enemy and challenge to overcome. The knock-on sedative effects of the painkillers makes my mind slow; it affects my sleep and this in turn makes me angry. I have to let the frustration out somehow. I have become a stronger person as a result of what has happened to me and, despite only having four inches left of my leg and having suffered a lot of pain for two years now, I think myself lucky. The injuries could have been worse: I have seen them arriving at Selly Oak and at Headley Court.

I look forward to returning to work preparing young commanders for their promotion courses in Pirbright; all I have to do is be free from the hidden injury inside, this deep and persistent pain.

ABOUT BLESMA

When thinking about putting this book together I asked 'Goolie' (his real name is Adam by the way) which charity he would like the proceeds of the book to go for. There are a number of military charities, all of which do incredible things to help service personnel, attending to different needs and providing specific support in the best way they can. Goolie did not hesitate in suggesting The British Limbless Ex-Serviceman's Association or BLESMA:

'BLESMA have been a pillar of support for me over the last two years. They were the first to support me outside the tri-service system and have provided advice on essential aspects of my recovery. Anything that I am worried about they will help me out with: as much as my family, my regiment or the Army might wish to help, they do not have the experience that comes with BLESMA. The support is provided by other amputees: if you are having a bad day they support you.' – LSgt Ball

The understatement of 'a bad day' sums up the courage and positive attitude of Goolie and the many others in his position. BLESMA being a membership association is in reality a fellowship of shared experience where amputee looks after amputee with very specialist and focused support. It is a lifelong commitment and would appreciate your further support.

If you would like to make a donation to BLESMA and add comments about the book, please visit:
www.justgiving.com/BLESMA-Afghanistan

giftaid it Under the new tax regulations, the Association is able to reclaim the tax on any donation, whether large or small, regular or one-off as long as the donor pays tax on his/her income in the UK.

ACKNOWLEDGEMENTS

Goolie, this book is for you. Thank you for your honest and humbling input.

First and foremost I would like to thank my wonderful sister Emily for trying to educate me in all things artistic for so many years and for putting on the most stylish and successful of exhibitions at the Royal Hospital Chelsea in March 2008.

I would like to extend my gratitude to Julian Platt and his team at Third Millennium Information (TMI) for publishing this book pro bono for BLESMA. It is a substantial risk for a publisher of their size, but it is symptomatic of their confidence and fast growth in their 10th year. Chris Fagg, Bonnie Murray and Matthew Wilson – thank you for making it so very straightforward.

I would also like to thank Emma Cahill for translating, Robert Worthington for the picture of me after the Incident and Key Player Publishing, Gabriel York, Charlie Leigh-Pemberton and Patrick Hennessey for their input, and especially General Sir Richard Dannatt for his very kind Foreword.

Finally, my heartfelt thanks to everyone I served with in the quality institution that is the Grenadier Guards, and I wish you all a safe return from Afghanistan in March 2010.

Arron Bance, I apologise for publishing the picture of you and your sunburn. I hope you have a safe second tour keeping everyone amused as ever.

Alexander Allan
London 2009

A limited number of prints of images in this book are for sale. Email: ARMEDWITHAFGHANS@GOOGLEMAIL.COM